THE LITTLE BOOK OF

Matisse

Laurence Millet

Flammarion

Alphabetical Guide

The alphabetical entries have been classified according to the following
categories. Each category is indicated with a small colored rectangle.

Please note that each alphabetical entry is cross-referenced
throughout the text with an asterisk (*).

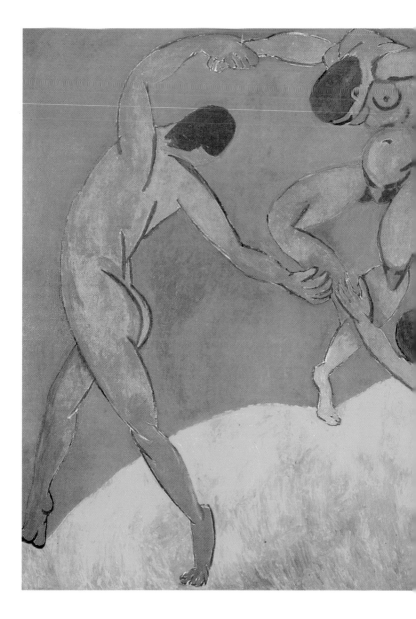

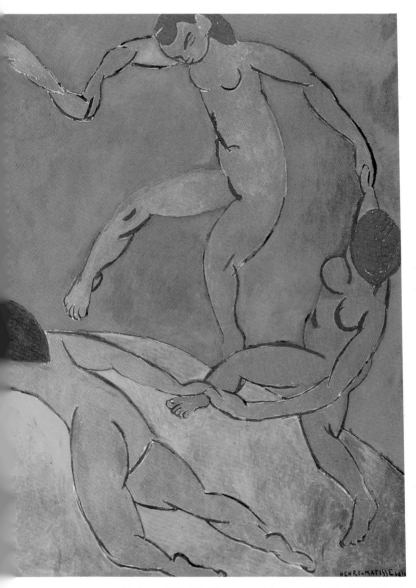

The Dance, 1909–1910. Oil on canvas, 8 ft. 6 in. x 12 ft. 10 in. (260 x 391 cm).
Hermitage Museum, St. Petersburg.

THE STORY OF HENRI MATISSE

I. THE CONQUEST OF MODERNITY 1869–1905
A. Heritage and tradition

Henri-Émile-Benoît Matisse was born on December 31, 1869 at Cateau-Cambrésis (now Le Cateau) in the north of France. He spent his childhood* at Bohain-en-Vermandois, Aisne, just south of his birthplace. At the age of eleven, Matisse entered the St. Quentin *lycée* (high school) where he won first prize in drawing. Although most of his art apprenticeship* was in Paris,* Matisse's native region of northeastern France had a Flemish art tradition that greatly inspired him. His father, Émile Matisse,* considered him to be the perfect successor to head the family business, but allowed him to study law in Paris. After returning to St. Quentin, the young Matisse became clerk to a notary, but he seriously neglected his work in order to study drawing at the local Quentin-de-la-Tour art school. At the age of twenty-one, he began suffering from agonizing bouts of colitis (inflammation of the colon), and he had to undergo an operation. To alleviate the boredom of convalescence, Matisse asked his mother to get him a paintbox. That is how he "suddenly had the revelation of life, of an exciting, ambitious, frenetic life." "…Before that, nothing interested me. Since then, I have had nothing but painting on my mind," he once explained with feeling. Having finally convinced his father of the need to continue his artistic training in Paris, Matisse enrolled at the Académie Julian in the fall of 1891. The Académie was a sort of stepping-stone to the École des Beaux-Arts. He rented an apartment in the Latin Quarter, overlooking the Seine on the Quai Saint-Michel. But he was unhappy with the teaching of William Bouguereau (1825–1905), and it was largely through coming into contact with the works of Goya (1746–1828) and Chardin (1699–1779) that he became aware that painting could have a deeply emotional content. His meeting with the painter Gustave Moreau* (1826–1898), in 1892, helped him to make sense of his discoveries. In 1895, he finally passed the entrance examination for the École des Beaux-Arts, an indispensable step toward gaining the right to exhibit at the official Salon and winning the prestigious Rome Prize. But the young painter left the studio* abruptly in order to embark on a new form of experimentation* in painting.

Henri Matisse at his villa, 1943–1944.

First Orange Still Life, 1899. Oil on canvas, 22.1 x 28.8 in. (56 x 73 cm). Musée national d'art moderne, Paris.

B. In the footsteps of Impressionism

In that same year, 1895, on the advice of Émile Wéry, his neighbor and fellow-artist on the Quai Saint-Michel, Matisse discovered the delights of the coast of Brittany, where he spent some time with his companion Camille* and their daughter Marguerite.* He was surprised by the savage aspect of the landscape, and of the local inhabitants, who still wore quaint costumes. He stayed for a while on the island of Belle-Île, but soon distanced himself from Wéry's Impressionism.* Matisse returned hastily to the mainland and spent time at Pont-Croix, Finistère. His enthusiasm for Brittany caused him to return to Belle-Île the following year. It is here that he met the Australian painter John Russell* (1858–1930) and became interested in the Impressionism that he had rejected the previous year. Over the summer of 1897, shortly before he separated from Camille, he began to apply all that he had learned from Monet. His meeting with Pissarro* (1830–1903) gave him confidence in his own work, while his use of an ever-more vibrant color palette took him further and further away from the precepts of Gustave Moreau.* He married his new companion Amélie* in 1898, and they spent their honeymoon in London, where he discovered that there was "a strong relationship in construction through color between Turner's watercolors and Claude Monet's paintings." In February, 1898, Matisse decided to follow in the footsteps of Van Gogh (1853–1890) and explore the brilliant light

of southern France. The ultimate destination was suggested to him by Amélie, who had just been reading Guy de Maupassant's *A Life*, which is set in Corsica. Corsica had the same powers of attraction as the Côte d'Azur, while being more affordable for a young painter. Matisse's output was considered to be "worthy of a mad, Impressionist epileptic," in the words of his friend Henri Evenepoel (1872–1899). It was incandescent with the Mediterranean light that initiated him into his passion for color. "Soon there came to me, like a revelation, the love of the materials themselves," he explained. The new style was far from being universally acclaimed, yet Matisse exhibited at the first Salon des Indépendants in April, 1901, and at Berthe Weill's the following year. He subsequently went through a difficult period during which he even considered abandoning painting. His father was no longer in a position to offer him financial support, and their relationship remained stormy. The whole family had been ruined by the Parayre* family scandal. Matisse, in despair, sought refuge in Bohain, to be near his family, but returned to Paris with his wife and son, Pierre,* in the fall of 1903, where he again took up painting while his wife resumed her career in millinery.

The Corsican Landscape. Oil on cardboard, 6.5 x 8.9 in. (16.5 x 22.5 cm). Musée national d'art moderne, Troyes.

C. Joining the Neo-Impressionists

Encouraged by Paul Signac* (1863–1935) to come and paint alongside him, Matisse, his wife, and the young Pierre,* arrived in

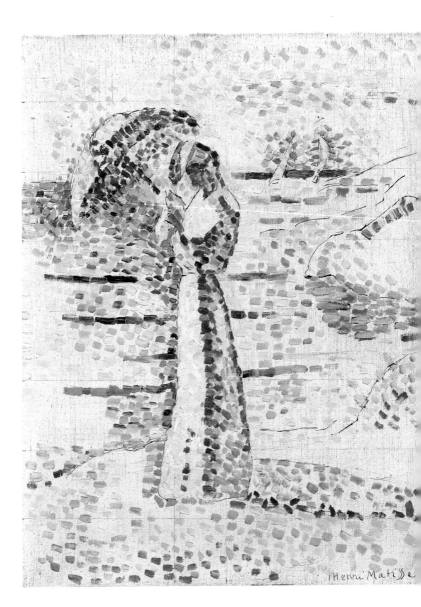

Young Woman with Parasol, Collioure, 1905. Oil on canvas, 18.1 x 14.8 in (46 x 37.5 cm). Musée Matisse, Nice.

Saint-Tropez in July, 1904. Here, he finally found the light that so enchanted him. Despite his rigid adherence to the Neo-Impressionist* doctrine, the modern spirit of the anarchist-theoretician in him encouraged him to use pure color once again and release his creative impulses. Like Signac and his friends, Matisse tried to interpret the energy of nature symbolically, producing canvases that were ever-more brilliantly colored and decorative. His care not to provoke a split in the artistic community sometimes provoked the anger of Signac, who was an ardent defender of a checkered, vigorous, and majestic brushstroke. The arrival of Edmond Cross

(1856–1910), another Neo-Impressionist, helped Matisse to decide between decoration and expression. The two men and their wives soon became firm friends. Both were convinced that their desire to move on to another style of painting would have to pass through a different phase of "thinking" about painting. They asked themselves how they could "organize their emotions [...] so as to be able to proceed to reproduce our feelings from the practical point of view. To make a choice between fragments, the details of the beauty that offered itself up to us. [To work out] how to put these fragments in order, being conscious of the end result. At that moment, we would be performing the work of an artist." By the end of the summer, Matisse had finally liberated himself from Impressionism* and, without having resolved his inner questioning, he chose the Divisionist route. The turning point was marked by *Luxe, calme et volupté** which was reasonably well received at the Salon des Indépendants. Signac bought the painting and proudly claimed to be its begetter, thus winning recognition for Matisse from his elders.

II. THE TRIUMPH OF COLOR 1905–1917
A. The Fauve experience

Like most of the painters of his generation, Matisse was irresistibly drawn by the idyllic setting of the Midi. After his trips to Corsica and Saint-Tropez, he decided to spend the summer of 1905 in southwestern France, near Perpignan and the Spanish frontier, at Collioure, a little village (now a fashionable resort) that his wife, Amélie* had discovered. Collioure had the discreet charm of a small fishing port and the unspoilt look of uncharted territory. Matisse, his wife, and their two sons took rooms in the only hotel in the village and lived the tranquil life enjoyed by the locals. From his bedroom, he watched the arrival of the fishing-boats, the preparations made by the fishermen, and the bustling pace of the women. He recorded on his canvases each movement and each detail with a surprising accuracy. At first he was faithful to Signac's* Divisionism, but with the arrival of his friend, André Derain* (1880–1954), he discovered "a new concept of light that consists in the following: the negation of shadow." As Derain explained it, "Here the light is strong, and the shade very pale. Shade is a whole world of clarity and luminosity that contrasts with the sunlight; these are what are called reflections." Drawing inspiration from the sensitivity of Cézanne's* curvilinear forms, Matisse

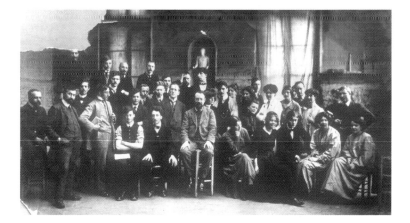

Matisse posing in his studio, 1909.

discovered that he could "extol all the colors together, without sacrificing any of them," thus increasing their power of expression. Hesitantly laying the foundations of what would soon become known as Fauvism,* this concept of expressive synthesis would be at the heart of what would become Matisse's own unique style. Henceforth, the feeling of color would permeate the entire canvas. The painter seems to have opened his window,* so as to let himself be invaded by "the atmosphere," drawing us into his colorful reverie. Matisse, the Fauve, "made the colors sing" more than ever.

B. Entering into the dance

In late 1905, Matisse rented the former Convent of the Sacred Heart on the Boulevard des Invalides in Collioure and painted *La Joie de vivre*,* discarding all the lessons he had ever learned. This anthology of his art of painting the nude was shown at the Salon des Indépendants the following spring; it displayed the treasures of voluptuousness that signify profound enjoyment. Matisse entered into happiness in the same way as the figures he depicts entered into the dance. He makes them twist and turn in the circular formation that so favors the permanent glorifying of color that can be found throughout his work, embodying the truly spiritual dimension of his art. For 27 years, Matisse dedicated himself to deconstructing and reconstructing this farandole, illustrated by the series of paintings entitled *The Dance*,* which was simply the expression of his feeling for space. *La Joie de vivre* marked a turning point for Matisse, just as much as it did for Picasso* (1881–1973), who responded to it by painting *Les Demoiselles d'Avignon*, the seminal work of Cubism.* A dialog subsequently ensued between the two

Matisse making sketches for *The Dance*.

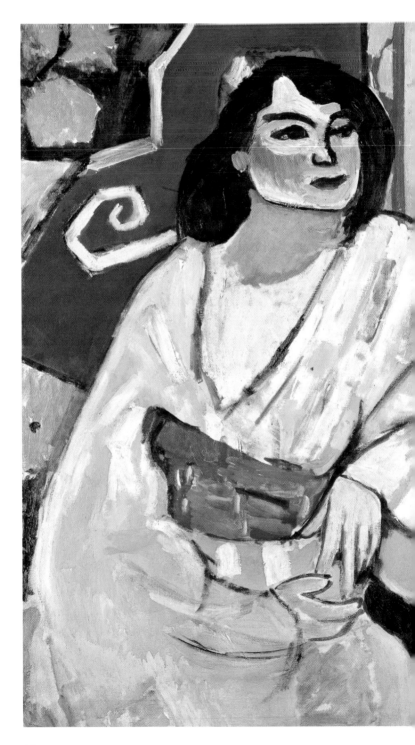

artists, which soon took on the appearance of a duel, but which did much to promote the development of the history of modern art. The sensuality with which Matisse painted women then became the very essence of his creative work. If hitherto "colors were destined to shock our senses with the spectacle," it was now a matter of producing an emotion by restoring nudity to the human body. With *La Joie de vivre*, Matisse confirmed his place at the head of the Parisian avant-garde into which the scandal of *The Woman in a Hat** had propelled him in the fall of 1905. In 1907, he exhibited *Le Luxe I*,* content in the monumentality that was emerging in his painting. In 1909, the artist left the Invalides district of Paris and took a house in the southern suburb of Issy-les-Moulineaux. It became the new laboratory for his experimentation,* and boasted a magnificent garden of which he was able to take full advantage.

C. After the disappointment of Algeria, the revelation of the Orient

After returning from Algeria,* Matisse began to explore sculpture.* Here he reinterpreted the drama acted out by the great nudes in the history of French painting. At this same period, he went back to his old love—ceramics. He had been initiated into the art of china-painting through the plates decorated by his mother. This had first awakened his feeling for color, and his love of ceramics developed through the applied arts taught in St. Quentin de la Poterie in France. He created a triptych with a bacchanalian theme in which plates prefigured the future themes of his subject-matter. This new facet of his work perfectly illustrates his concept of painting, inspired by his knowledge of the Orient:* "Expression and decoration are only one and the same thing. Yet if," stated Matisse, "revelation always came to me from the Orient" (it was the great exhibition of Islamic art held in Germany in 1910 that crystallized his aspirations), "it was in

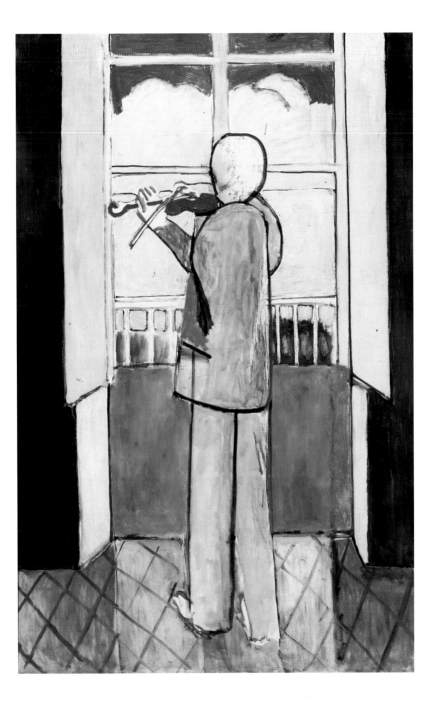

Munich that I found new confirmation of what I was searching for." Matisse also visited Andalusia in Spain, where he was able to learn more about Islamic art by studying Moorish art. He then visited Morocco,* on the advice of Albert Marquet* (1875–1947), in order to discover the ideal subject-matter. He traveled to Italy in the footsteps of Giotto and to Moscow to supervise the installation of *The Dance** and *The Music*,* but it was in Morocco that his painting finally liberated itself from Fauvism* and became the perfect combination of form and color.

The outbreak of World War I caused Matisse's anxieties to return, but drew him closer to his fellow artists. After he was discharged from the war, Matisse found temporary refuge once again in Collioure.

III. THE DREAM 1917–1954
A. Intimacy regained

Matisse spent some time in Nice in 1916, returning the following year. He took advantage of the trip to visit Auguste Renoir (1841–1919) at his home in nearby Cagnes-sur-Mer. Renoir did not like Matisse's work, but admitted that he was "certainly a painter." Matisse gradually moved his studio from Issy-les-Moulineaux to Nice, staying in the Villa des Alliés and later in the Hôtel de la Méditerranée. There, he produced a series of paintings of his artist's studio,* and displayed his talents as a violinist, playing in his bedroom in the cool dawn air. In 1918, Matisse took a trip to Antibes to visit the painter Pierre Bonnard* (1867–1947), with whom he would henceforth share a love of the decorative and the intimate. Matisse's work in the early Nice period is impregnated with the gentle sea breezes of the Riviera, illustrating with great sensuality the intimate and feminine atmosphere that surrounded the artist. His models,* who were shaded by the trees in his garden at Issy-les-Moulineaux and later by their parasols from the heat of the Midi, were brightly clothed and arranged beside screens and mirrors in attractive interiors. As evanescent as the fragrances borne on the breeze, the light ensures the harmony of compositions in which brightly contrasting colors and exuberant patterns mingle. In 1920, Matisse agreed to produce the sets and costumes for the third version of *Song of the Nightingale,* to be performed by Serge Diaghilev's (1872–1929) Ballets Russes. The music for this lyrical fairytale, borrowed from Chinese folklore, was composed by Igor Stravinsky (1882–1971) and choreographed by Leonid Massine (1896–1979) who became friendly with the painter. The following year, he took an apartment on the

Preceding page: Algerian Woman, 1909. Oil on canvas, 31.9 x 25.6 in. (81 x 65 cm). Musée des Arts décoratifs, Paris.

Violin Player at the Window, spring 1918. Oil on canvas, 5 ft. x 3 ft. 2.6 in (150 x 98 cm). Musée national d'art moderne, Paris.

Nude on a Blue Cushion, 1925. Lithograph, 24.3 x 18.8 in. (61.7 x 47.8 cm). Private collection.

Place Charles-Félix, converting it into a sort of oriental theater, the ideal setting in which to place his delightful odalisques, the objects of his fantasies. Matisse's dream had achieved pictorial fulfillment.

B. Toward a different light

The 1920s were marked for Matisse by major exhibitions in New York and Copenhagen, a second trip to Italy, the marriage of his eldest daughter, Marguerite,* and the departure of his son Pierre.* Matisse did not paint at the easel for five years. He began dreaming of "a different light," and pursued this quest first in the south of France, then in the Orient.* He considered taking a trip "to the Isles, to observe the tropical night and the dawn light that probably have a different density."

In February, 1930, Matisse left for Tahiti, hoping that there he would perceive "something other than real space," for, he said, "having worked for forty years in European light and space, I still dreamed of different proportions that might perhaps be found in the other hemisphere. I have always been conscious of a different space in which the objects of my reverie were forming." Although intoxicated by the scent of frangipani and tiaré, Matisse was soon overcome by the humid heat. He was unable to work, merely taking a few photographs. Oceania was full of promise, yet he never found the "different space" that he had sought. But he discovered a new light, a light that was "all golden, while ours is silver." New York and Los Angeles, where he had stopped briefly before sailing for Tahiti, had made a strong impression on him. Overwhelmed

Hair. Study for *Poésies,* a book of poems by Stéphane Mallarmé, 1931. Etching, 13.2 x 9.8 in. (33.5 x 25 cm). Private collection.

Matisse using
the width of
the room as
a working area
to decorate
the Chapel
of the Rosary
in Vence.

by the crystal-clear light of New York, he wrote to his wife, "if I were not accustomed to following my decisions to the end, I would go no farther than New York, so much do I find it is a new world here; it is great and majestic like the sea [...]. It is clear, the great American clarity." Matisse returned to the United States at the end of 1927 in order to receive the Carnegie Prize, awarded by the Carnegie Institute in Pittsburgh, Pennsylvania. Picasso won the prize the following year; Matisse was on the jury. Matisse took advantage of his trip to Pennsylvania by stopping in Merion to visit Dr. Barnes, who already owned *La Joie de vivre,** and who now commissioned his first architectural work, *The Merion Dance.**

C. "Entering into painting"

While creating this huge and exhausting composition, Matisse devoted himself increasingly to applied art. In addition to drawings for tapestries, costumes, and the stage sets for the ballet *Rouge et noir*, he made etchings to illustrate the *Poésies* of his friend Stéphane Mallarmé, and engravings for James Joyce's *Ulysses*. In November, 1938, he left his apartment on the Place Charles-Félix and moved to the former Hôtel Regina on the Cimiez hill. This is where he spent the early years of World War II, in anguish and torment, since he had no news of either Amélie,* his wife, or Marguerite,* his daughter. He was hospitalized in September, 1937, and operated upon in January, 1941 for duodenal cancer, but he made a miraculous recovery. He was nursed by Monique Bourgeois, who initiated the Vence* chapel project. Matisse started "a second life"; among his work of this period is a lovely series of portraits* of the future Dominican nun. He also produced a wonderful album of drawings, with a preface by Louis Aragon, entitled *Themes and Variations*. While confined to a wheelchair, he reinvented painting, and developed the technique of paper cut-outs or découpages* that he had originally used for *The Merion Dance.** Since his "designed inspiration" was complete, Matisse now wanted "to enter into painting." In 1943, the artist moved to Vence, when Nice came under threat of bombing raids. He bought a villa that reminded him of Polynesia, and which he called "Le Rêve" (The Dream). In his decoration of the chapel at Vence, a perfect synthesis of his drawing style, of color, and of the light, Matisse gave his work the monumental dimension to which it was so well suited.

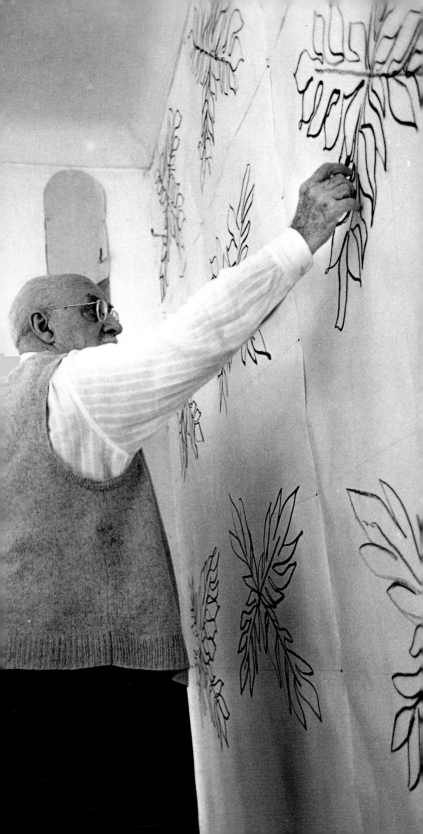

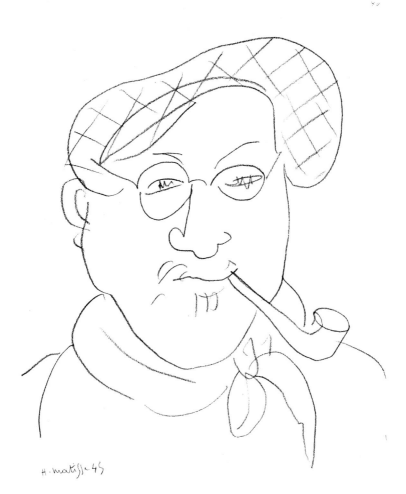

H. matisse 45

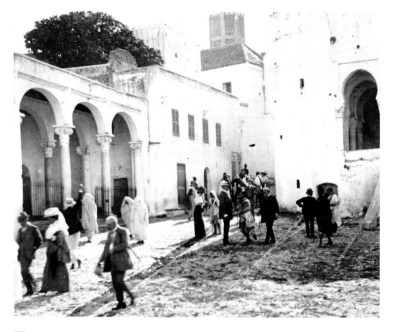

Algeria

In April, 1906 Matisse made his first trip to the Orient,* boarding a ship at Port-Vendres near the Spanish border. He had familiarized himself with African art, of which more and more could be seen in the art galleries of Paris,* and he considered Algeria to be the ideal setting for total immersion in tribal art, hoping to find a new impetus for his work. Unfortunately, he found Algiers to be suffocating:"a foul version of Paris," as he wrote disappointedly to his friend Manguin*; a place that disgusted him. His trip to the Batna Mountains, which led him to Biskra, however, revealed a blindingly bright light and dazzling colors that he found utterly fascinating. Eastern promise stopped there, since "the inhuman side of nature" found no favor in Matisse's eyes, who on his return was more preoccupied with problems of volume, which he resolved by devoting himself to sculpture.* In his *Blue Nude, Souvenir of Biskra,** which is so crucial to the history of painting, but which is the only record of his stay, the artist merely retains the memory of an exotic landscape, using it as the background for an odalisque who is far removed from any orientalism. Yet on his return, he decorated his canvases and his studio with the pottery and carpets that he had brought back with him along with his memories. While certain images, such as those of the goldfish,* re-emerge in his later work, his trips to Morocco* would be far more productive.

Amélie

Matisse met Amélie (1872–1958), daughter of Armand and Catherine Parayre,* while attending a wedding on October 16, 1897. Their meeting had all the ingredients of a whirlwind romance,

Tourists in Algiers.

Self-portrait, 1945. Pencil, 16.5 x 12.7 in. (41.8 x 32.3 cm). Private collection.

and the lovebirds married the following January. The young woman had a mother who was devoted to her, and from whom she inherited the proud bearing of the women of Toulouse. The memory of her pirate ancestors gave her a taste for adventure, and caused her to throw herself wholeheartedly into Matisse's struggle to have his love of painting recognized. After a short trip to London, where Matisse studied the work of Turner (1775–1851), the couple's adventure really began in February, 1898, when they visited Corsica for the first time. Stimulated by the radiant Mediterranean light, Matisse produced a series of portraits* of his beloved and loving wife whose courage and loyalty he praised. These portraits of Amélie are a foretaste of his love for color and materials. Always ready to help her husband fulfill his aspirations, Amélie Matisse went so far as to pawn her valuable jewelry so that he could afford to buy Cézanne's* *The Three Bathers*, in a transaction in which she became the catalyst. Jean* was born of their union in 1899, but their financial difficulties caused Amélie to open a millinery store on Paris' Rue de Châteaudun. She had learned dressmaking and become known as a milliner at "La Grande Maison de modes," a store on Boulevard Saint-Denis owned by her aunt. The young wife warmly welcomed little Marguerite* into her household. Marguerite, aged four, was the love-child of Matisse's previous romantic liaison with Camille. Pierre,* the second son, was born in 1900. The store did not make money and was forced to close. A subsequent scandal involving her parents, Armand and Catherine Parayre,* somewhat depressed her, but she bounced back in the summer of 1903. She would help her husband over his insomnia by reading to him at length, and she often served as his model.* The presence of Madame Matisse as an animated but discreet figure in the Corsican landscapes, confirmed in the paintings produced in Saint-Tropez, is repeated in the work that the painter did in the summer of 1905 in Collioure. Matisse and his wife visited Italy in 1906, enabling him to fulfill his dearest dream. Amélie was very popular with her husband's friends and family, who realized that she was the ideal wife for their prodigal son. The *Portrait of Madame Matisse** that he painted in 1913 would be the last of its kind. The artist settled in Nice without her, thus confirming their separation, even though Amélie visited him

Madame Matisse,
Ajaccio, c. 1898.

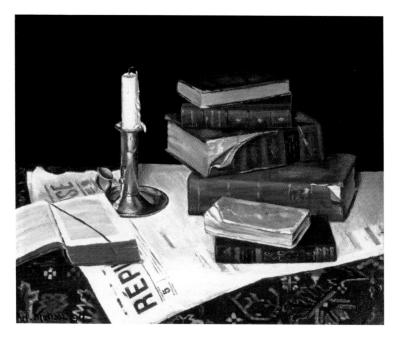

Still Life with Books, 1890. Oil on canvas, 14.9 x 18.1 in. (38 x 46 cm). Private collection.

regularly and he sometimes spent the summer with her in Paris. A number of other models began to supplant Amélie, who had become afflicted with rheumatic pain. She still accompanied him on some of his trips, but he went to Tahiti alone. In 1937, she left him for good. Like Marguerite, she became involved in the French Resistance during World War II and was imprisoned six months before the Liberation.

■ Apprenticeship

Following his revelation that he was meant to be a painter, Matisse bought the *Manuel général de la peinture à l'huile [General Manual of Oil Painting]* by Frédéric Goupil, a teacher at the Académie Julian in Paris.* He produced a still life* that he called *My First Painting.* Thereafter, in addition to his work as a notary's clerk, he would visit the art school that was opened in 1782 in St. Quentin by the greatest local painter, Quentin de la Tour (1704–1788). The school was firmly attached to the academic tradition of art, and based its teaching on incessant copying and recopying of details of architectural drawings and moldings from the classical period. Painting was not even on the agenda, and only the most talented students won the right to vary their pleasure by recopying the pastels created by the master and founder of the school.

Matisse was introduced to open-air painting by studying under Emmanuel Croizé, a refugee from the regional academy of art. He painted his first landscapes at sunset. Croizé soon spotted Matisse's talent and encouraged him to pursue an artistic career, but he was forced to stop his activities when the school deemed he had transgressed their rules by encouraging his students to paint outside the studio setting, and especially by teaching them the art of color. Matisse consequently decided to leave St. Quentin and its academic rigidity and try his luck in Paris. But he still had

hurdles to overcome: he had to confront the hostility of his father, who felt increasing incomprehension and frustration with his son. It seemed to Émile Matisse* that Henri was not only destroying all the hopes his father had for his promising career, but was now ridiculing his family by rebelling against its institutions. After interminable discussions and thanks to the insistence of Henri's compliant mother, Émile finally agreed to permit his son to go to Paris, and even decided to give him a monthly allowance for a year. Once in Paris, the young Matisse presented himself to the undisputed master of official painting, William Bouguereau (1825–1905). As the symbolic figure of the classical ideal, the painter occupied an important place in the art establishment and had the power to decide who was and who was not to be allowed to exhibit at the Salon. Bouguereau advised Matisse to join a class at the Académie Julian to further his artistic training before taking the competitive examination for entry into the École des Beaux-Arts. Matisse soon became disenchanted, however, because, although he learned thoroughness and perseverance from this inveterate hard worker, he disapproved of Bouguereau's love of ornamentation. After seeing the work of Turner (1775–1851), other revelations were in store for Matisse. There was Goya (1746–1828), whom he discovered in Lille, and Chardin (1699–1779), whose work he copied on many occasions in the Louvre and who influenced him throughout his student years. After tiring of the Académie Julian, Matisse asked to be taken on as a pupil by the master of Symbolism,* Gustave Moreau,*

who accepted him without an entrance examination at his studio in the École des Beaux-Arts. This is where Matisse found the necessary support for his studies. It was also at the École des Beaux-Arts that he met Manguin* and Marquet,* future members of the Fauvism* movement. At the same time, he took evening class at the École des Arts Décoratifs (School of Applied Art), hoping to be granted a teaching diploma. Matisse was now ready to make his debut* on the Parisian art scene.

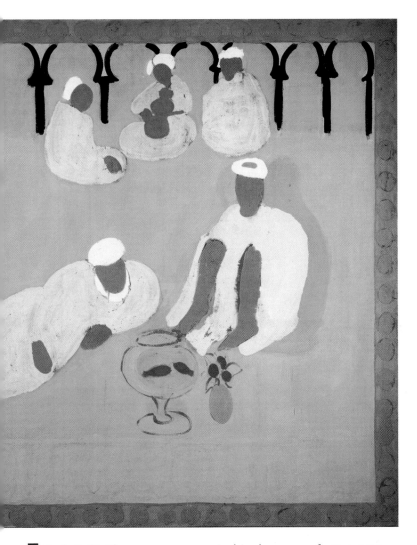

■ Arab Café, The

Bathed in luminous and diaphanous shadow, *The Arab Café* has an ethereal air. Only the colonnade, punctuated by the presence of four figures at the top of the composition, structures the pictorial space and introduces the concept of depth, thus breaking with the abstraction. There are echoes here of the goldfish* in their bowl, with the two main characters, placed in the center of the painting, in a diagonal line, seeming to float like clouds in the sky. Everything is summarized in the masses of the same color splashed with patches of ocher, evoking their brown flesh. Yet, through this extreme simplification, inspired by the Persian miniatures discovered by Matisse in Munich in 1910, his acute sense of observation can be discerned, giving these figures in their relaxed poses a real and majestic dimension. Here, sheltered from the noise of the city, all the action rests with whatever animates the figures: those in the background who dream or chat, as well as those in the

The Arab Café, 1913. Glue painting on canvas, 5 ft. 9.3 in. x 6 ft. 10.2 in. (176 x 210 cm). Hermitage Museum, St. Petersburg.

foreground who are contemplating the goldfish. The dilute background of the painting, so light and vaporous, shrouds the composition in a silent, almost aquatic, harmony, a reflection of the serenity that reigns in the café. According to Pierre Schneider, *The Arab Café* is "the culminating work" of the Moroccan period, and can be read as "the third part of the triptych in which the things considered most sacred to Matisse are affirmed; the other two parts [*The Dance** and *The Music**] having been completed earlier."

◼ Bathers by a River

The canvas known as *Bathers by a River* had been started in 1909 as a reinterpretation of *Young Girls beside the Seine* by Gustave Courbet (1819–1877). Matisse completed the definitive version of the work in 1917. Young girls stand in a stiff, hieratical pose, like columns in a Moroccan landscape, stylized to the extreme. Matisse's *Bathers* are very similar to the series of backs that he was sculpting at the same time, and are a form of homage to the *The Three Bathers* by Cézanne,* just as they have something in common with the austere art of Puvis de Chavannes* (1824–1898). All the primitivism* that Matisse shared with the Fauves and which he later developed through contact with Cubism* has been placed in the service of decorative expressiveness, whose construction seems to constitute a response to

Bathers by a River, 1916. Oil on canvas, 8 ft. 7 in. x 12 ft. 10 in. (261.8 x 391.4 cm). The Art Institute of Chicago.

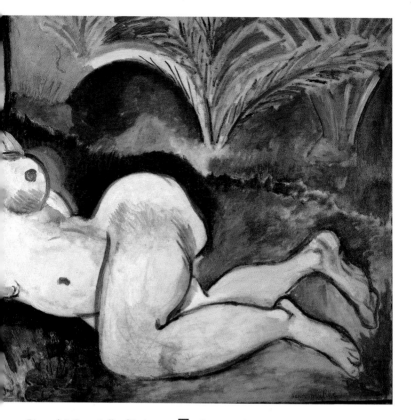

Picasso's* *Demoiselles d'Avignon.* By leaving material traces of the path of his thought, Matisse emphasizes the fragility of the images, a vanity to which the immediacy of the cut-outs or gouaches découpages* would respond with a disconcerting simplicity. It is in this perspective of his relationship with time that the canvas of the *Bathers by a River* is an extension of the artist's dream of paradise. As Pierre Schneider explains, "Paradise can only be grasped from within history that renders it vulnerable, but also accessible." He adds, "The eternity of the image that suspends time is within time." In other words, the image is "the eternity of an instant, god in time." It is in this sense that the distortions used by Matisse in *The Dance** and *The Music** and thereafter are vehicles for the sacred.

■ Blue Nude, Souvenir of Biskra

After the disappointment of Algeria,* Matisse looked on Collioure in a new light, and in the summer of 1906, it inspired him to take up sculpture* once again. In the fall, he modeled a nude—*Reclining Nude I (Aurora)*, but it fell on the studio floor and broke. Before sticking the pieces together again, Matisse decided to recreate his sculpture as a painting, and this is how *Blue Nude, Souvenir of Biskra* came about. Despite the fact that the model looks rather uncomfortable, due to the artist's desire to retain the integrity of the sculptured form, her pose is reminiscent of *The Birth of Venus* by Cabanel (1823–1889) or *Olympia* by Manet (1832–1883), although it differs from them. *Blue Nude, Souvenir of Biskra* has something

Blue Nude (Souvenir of Biskra), 1907, Oil on canvas, 3 ft. x 4 ft. 7.3 in. (92 x 140.4 cm). The Baltimore Museum of Art.

BONNARD, PIERRE

Pierre Bonnard,
Nude in the Bath,
1937.
Oil on canvas,
3 ft. x 4 ft. 10 in.
(93 x 147 cm).
Musée national
d'art moderne,
Paris.

of the monumental power of an African sculpture, imposing itself over the whole canvas and accentuating the frontality of the volumes, the distortion and accentuated lines of the body. By placing the figure in a setting of palm-trees and shrubs, the only explicit reminder of his trip to Biskra, the artist gives his work a decorative aspect that contrasts with the cruelty of a geometric, almost disjointed body. In order to accentuate its volumes, he has pushed to an extreme the use of blue that Cézanne* revealed to him "to be able to smell the air," that is to say, to convey a subtle feeling of depth. This was the only painting Matisse exhibited at the 1907 Salon des Indépendants. This figure, whom Pierre Schneider considers "to be located halfway between the sacred and the profane," extends the theme of a garden of Eden that the artist first tackled in *Luxe, calme et volupté,** and, in its creation, showed Matisse how to use distortion.

■ Bonnard, Pierre

Like Matisse, Pierre Bonnard (1867–1947) began as a law student, but soon abandoned law in order to study art. He was a product of the Académie Julian and the École des Beaux-Arts, where he met the future Nabis and was very impressed by the Gauguin* retrospective he saw in 1889, as well as by the Japanese art exhibition held in Paris* the following year. Bonnard was nicknamed "*le nabi japonard*"

by his friends; this most intimist of the Nabis was inspired by his discovery of Impressionism.* He began using paler colors in his palette, though he retained the harmonious color contrasts he had used previously, and his painting opened up to the outside world. From Edgar Degas (1834–1917), he retained the incessant rhythmical movement associated with the ballerinas he painted, and adopted a plunging perspective that suspended the vision of the spectator. Yet Bonnard probably owes to Auguste Renoir (1841–1919) his wonderful ability to render the tactile nature of objects. As if saturated with the humidity of the atmosphere, his canvases of nudes bathing seem to be covered with a fine layer of steam, from behind which his warm colors shine through. Bonnard had a perception that was more architectural than Impressionist, and the purity of his colors expanded and opened out like flowers when they came into contact with the Mediterranean light, as they did in 1909. The products of a great sense of elation, the colors radiate from everywhere in order to melt into a magical universe governed by a delicate feminine presence, that of Marthe, the artist's wife and the sole model for his aspirations. Bonnard bought Matisse's *Studio Interior, Collioure* in 1912, confirming the latter's recognition by his fellow artists, a process that was begun in 1905 by Paul Signac* (1863–1935).

The Reader, 1895.
Oil on wood,
24.2 x 18.9 in.
(61.5 x 48 cm).
Musée national
d'art moderne,
Paris.

Camille

Caroline Joblaud, known as Camille (1873–1959), was the daughter of a carpenter and was orphaned at a young age. She was raised in a children's home in the L'Allier region by nuns, and later moved to Paris,* where she worked as a milliner. Like Matisse she loved beautiful materials and silky fabrics,* and was the incarnation of youthful elegance and true Parisian chic. She was nineteen years old when they met at Gustave Moreau's* studio; her dark, expressive eyes attracted the artist. Camille was the first human figure to animate Matisse's still-life* paintings, and she became his mistress, before giving birth to a little girl who was baptized Marguerite.* Against all the strict middle-class conventions of his day, Matisse rented an apartment and lived with his companion on the Quai Saint-Michel, where she soon became the dream model* of his first portraits.* Camille was painted by the artist in 1895 in homage to Corot (1796–1875) and this painting, *The Reader*, marks an important stage in

Matisse's life. As the first of his works to be purchased by the French government, it is evidence of an early recognition, and initiated a series of commissions. Furthermore, Camille's lively personality enchanted Matisse's friends, and the trips they took to Brittany in the company of the painter John Russell* would always be fondly remembered by her. Subsquently, as their financial difficulties increased and Matisse obstinately insisted on continuing on his unique way, Camille rebelled, and the couple eventually parted company during the winter of 1897. The summer saw them reunited once again in Belle-Île, but Henri returned to Paris alone, and it was then that he met the woman who was to become his wife, Amélie.*

Camoin, Charles

Like Rouault,* Manguin,* and a few others, Charles Camoin (1879–1965) was a product of Gustave Moreau's* studio. In 1898, Marquet* introduced him to Matisse, who at the time was studying at the Académie Carrière. The three shared their fate as unknown artists, and were in the habit of taking walks together in the pursuit of any figure or scene that they might sketch, but their work attracted neither collectors* nor dealers.* Camoin was very impressed by his meeting with Cézanne* in 1902, and started a regular exchange of letters with him. He was also very fond of Marquet; he produced a portrait of him that was clearly inspired by Cézanne's work, though his nonrealist vision of color brought him closer to Matisse. Camoin was very sensitive to the renewed Divisionist tendency that Matisse had brought back from his stay at Saint-Tropez, but he swiftly lapsed into the discordant and unconstrained esthetic of emerging Fauvism.* He later accompanied Matisse on the second trip to Morocco.* He was wary of any esthetic thought, however. In 1955, he declared: "My instinct as a colorist drew me to him, but that which remained instinctive with me soon developed into theory in his case." Nor did he give in to the Cubist adventure, taking refuge in the Impressionism* of Renoir (1841–1919) whom he met in Cannes in 1918. His contact with the old master caused him to adopt a lighter color scheme for his palette; this perfectly matched the tranquil harmony of his comings and goings between Paris and Saint-Tropez. His friendship with Matisse was fueled by abundant correspondence.

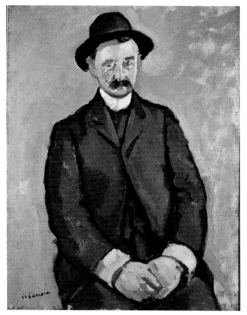

Charles Camoin, *Portrait of Albert Marquet*, 1904. Oil on canvas, 3 ft. x 28.6 in. (92 x 72.5 cm). Musée national d'art moderne, Paris.

■ CÉZANNE, PAUL

Matisse was captivated by the way Paul Cézanne (1839–1906) questioned painting, and was probably fascinated by the break he created with perspective as Alberti (1406–1472) had defined it in the fifteenth century, a clean break that was nothing more or less than the expression of abstraction. And yet Cézanne, an artist who came from a conservative, Roman Catholic, middle-class home, owed his discovery to his obstinate intention to paint and repaint the same motifs. His early work was passionate and romantic, but his palette became brighter in the 1870s. The simplification that is so characteristic of his constructive painting became systematic after 1896. Thus, starting in 1879, Cézanne produced what he called "Poussin on nature," that is to say that he made spatial unity and the unity of colored intensity coincide, while simplifying the details of Mediterranean landscapes that he reconstituted. In other words, Cézanne solicited reality but gave free rein to his imagination. For him, "art is a harmony that is parallel to nature." It was at this period that he painted *The Three Bathers*, completed in 1882 and purchased by Matisse from the dealer* Ambroise Vollard in 1899. The theme of the nude in nature is one that was dear to Cézanne; it is one that he tackles without worrying about eroticism, but which constitutes a means of progressing in his pictorial

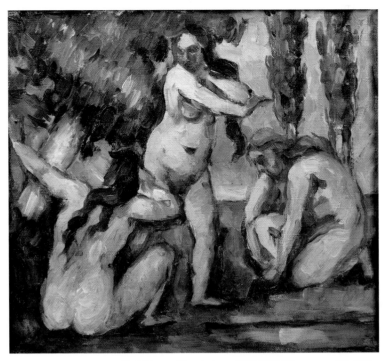

Paul Cézanne, *Three Bathers*, c. 1875–1877. Oil on canvas, 8.7 x 7.5 in.
(22 x 19 cm). Musée d'Orsay, Paris.

research. The structure is that of a pyramid, and the canvas owes all its dynamism to the interplay of the curves of the trees and those of the women, just as there is interplay between the cool tones of the harmony of color that constitutes the space. The *Three Bathers* is a combination of the lessons learned from Pissarro,* Monet (1840–1926) and Degas (1834–1917), that caused Matisse to abandon the construction of volumes through modeling and to adopt a system of "colored volumes," without altering the radiating power of color. As he explained in 1956, this was at the foundation of his art, and it also encouraged him to venture into nude painting and sculpture.* In the summer of 1905, in Collioure, Matisse, who was in a flurry of self-doubt as to the limitation of Divisionism, once again searched the writings of Cézanne in order to find the solution to his problems of prioritization. "Drawing and coloring are not separate entities.... When color is at its richest, shape is at its fullest." Intimately linked with Cézanne, Matisse defined him as "a sort of good God of painting" who had taught him the spirituality of the arabesque. Throughout his life, he continued to follow Cézanne's example and to buy his paintings. He declared in 1949, "I owe my art to all the painters," but he also confessed, "In modern art it is indubitably to Cézanne that I owe the most."

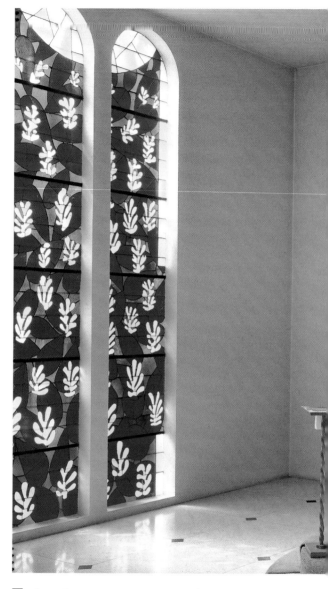

◼ Chapel at Vence, The

In 1942–1943 Matisse produced a series of portraits* of Sister Jacques-Marie, his nurse during his recovery from cancer. In September 1946, in the foyer of the Lacordère Home in Vence, she sought Matisse's advice in decorating the bare hangar that served as a chapel for the Dominican nuns. First the artist corrected the sketch-plan she had made, and then he offered to create the stained-glass windows. Finally, he proposed that he would decorate the Rosary Chapel himself. In his diary, Matisse tells the story in the third person of how the project came to fruition: "[…] the interest he had found in studying it, like a game, in musing about the possible stained-glass windows, in thinking about the need to open up or even overstep his art, his illness, and his old age; all of

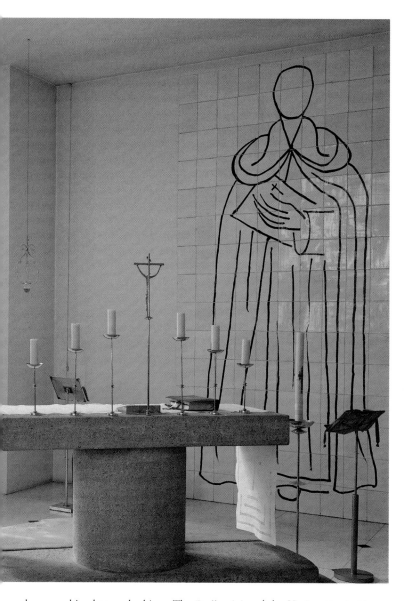

these combined to make him aware of new needs, of the possibilities of his art of which he himself had been unaware, and of the spirit of the Church." In December, 1947, Brother Rayssiguier visited Matisse to talk to him about the project. If he was surprised by the seriousness with which Matisse tackled the subject, the young friar soon understood where his interest in it lay—the light.

The *St. Dominic* and the *Virgin and Child* on the right-hand side of the chapel are made of large white ceramic tiles decorated with black line drawings. "This results in a black-and-white image in which white dominates; the density of this balances the bright surface of the facing wall, which consists of floor-to-ceiling stained-glass windows. These express, in similar forms, the idea of foliage, always of the

Chapel of the Rosary, Vence : the altar and the Tree of Life, 1948–1951, stained glass window.

same origin, being the leaves of a tree that is typical of the region. There is a cactus whose flat leaves are covered in spines, flowering with yellow and red blooms. The stained-glass windows consist of three very definite colors of glass—ultramarine, bottle green, and lemon yellow—combined in each section of the window." The figures of St. Dominic and of the Virgin radiate a profound sense of peace that perfectly complements the contemplation to which they invite the viewer. "In summary, the ceramics are the spiritual essence and explain the meaning of the building." *The Way of the Cross,* which constitutes the third panel of the ceramic tiles, was originally designed in the same decorative spirit as the other two. "But, finding himself caught in the drama of this moving story, he overturned the layout of his composition. The artist quite naturally became the principal actor. Instead of reflecting the drama, he experienced it, and he expressed it thus." The spectator is caught up in the drama of the Passion and shares the painter's feelings and emotions. Finally, the patches of color in the stained-glass windows project into the white space and add a soft blue and yellow light to the presence of the patron saint and the Virgin Mary. As "the culmination of a life," through the ascendancy of light, the Rosary Chapel restores, on a monumental scale, the balance of the gouaches découpages* and the pages of writing in *Jazz.* Enter this chapel, and you will enter into the light…

■ CHILDHOOD
Between the Grayness of the North and the Flemish Tradition

Henri Matisse, the son of Émile-Hippolyte-Henri Matisse* and Anna-Héloïse Gérard, spent his childhood ten miles from the town of Cateau-Cambrésis, at Bohain-en-Vermandois, a village in northern France. The district was famous for its luxury fabrics,* as well as for being a big sugar-beet production center. Although he grew up in the typically gray weather of northern France, with its cold, dreary winters, Matisse also witnessed the burgeoning industrialization, stimulated by the late nineteenth-century expansion of the railroad network. From Bohain to the regional capital St. Quentin, the countryfolk of Picardy were suddenly thrust into the realities of modern life. Yet most of Matisse's childhood memories are linked to nature, birdsong, or the ancient burnt oak at the Château de Bohain, about which so many stories and legends were told. Another element that fired his imagination and awakened his interest in clowns, acrobats, and actors was the daily theater of the street. It was in the street that he observed life as it was then lived, listening to the stories told by the locals when they brought out their chairs in the summer and sat around gossiping. Matisse was brought up with an acute sense of honor; the nationalistic and Catholic education he received was tinged with bitterness, the result of the Prussian occupation. Handed down to him by his father with the straight-talking that is typical of the north, this provided a foretaste of the tenacity and also the pride with which Matisse would always remember his origins in Picardy. His frequent attacks of colitis could have been a sign of his special sensitivity, a psychological rebelliousness, or mere physical frailty. Though they had often forced him to be bedridden, they disappeared completely as soon as he left St. Quentin.

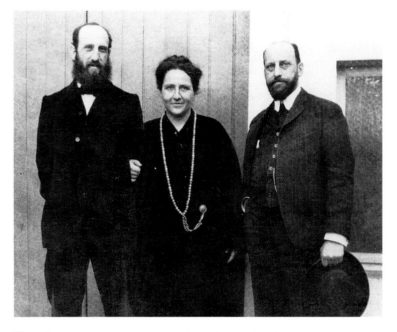

◾ Collectors

The first collectors to play an important role in Matisse's life were the writer Gertrude Stein (1874–1946) and her brother, Leo. Although they hesitated when faced with the daring paintings exhibited at the Berthe Weill gallery, the two Americans eventually acquired *The Woman in a Hat*,* which placed Fauvism* firmly in the field of modern art. As lovers of both art and literature, they became friends with Matisse and Picasso,* as well as with many other future great Parisian artists. Dr. Claribel Cone of Baltimore and her sister, who were also friendly with Gertrude Stein, purchased *Blue Nude, Souvenir of Biskra** in 1926, and later acquired many other works that can currently be seen in the Baltimore Museum of Art. It was for these two sisters that Matisse painted *Pink Nude** in 1935.

Another collector who played a decisive role in the life of Matisse was the Russian connoisseur, Sergei Ivanovitch Shchukin. Following a visit to the Salon des Indépendants in 1906, Shchukin asked the famous dealer,* Ambroise Vollard, to introduce him to Matisse. He purchased a still life* from him, telling him, "If I can bear it, and it continues to interest me, I'll keep it." Such was the impact of the painting on him that Shchukin later commissioned Matisse to produce *The Dance** and *The Music** for his mansion in Moscow. After the Russian Revolution, the Shchukin Collection became the property of the Hermitage Museum in St. Petersburg. Another benefactor, Dr. Barnes, a hugely wealthy art-lover, began collecting the painter's work from 1914 onwards, eventually commissioning him to paint *The Merion Dance.**

Leo, Gertrude, and Michael Stein, c. 1906.

■ CONVERSATION, THE

This is definitely the painting by Matisse that has been most often written about. In the painting, a man is standing in profile opposite a woman who is seated, with an undefined space between them. There is a seriousness about the scene, and it is imbued throughout with an intense blue that contributes to its sacred character. According to Jack Flam, this is an imitation of the stele of King Hammurabi, preserved in the Department of Antiquities in the Louvre. The painting was created at the same time as *Harmony in Red—The Red Dining Table*,* which Matisse had originally intended to paint in blue. Pierre Schneider believes that *The Conversation* shows a quarrel. He claims that the figure wearing striped pajamas is Matisse, and the other figure is his wife, Amélie.* The contrast between the darkness of the interior and the brightness outside, introduced by the open window,* translates the concept of discord: "The conversation is, in fact, an interrupted conversation—interrupted by the eruption of a brilliant light from outside that destroys the intimacy...." This powerful duality, expressed by the contrast between the feminine curves and masculine verticals, can also be found in other paintings by Matisse, such as *The Painter and His Model*.* It is also echoed in the balustrade, an element symbolic of the separation of two worlds, as well as of their permeability. This is what there is "between" the things that interest Matisse, just as there is "between" the figures, and it is this that he

The Conversation, 1911. Oil on canvas, 5 ft. 9.7 in. x 7 ft. 1.5 in. (177 x 217 cm).
Hermitage Museum, St. Petersburg.

tried to depict subsequently. Schneider notes, however, that this dualism does not preclude unity—a unity of rhythm and a unity of space—that means that, finally, "the figures reveal their complicity." In fact, in this confrontation—which can only have been the concrete expression of his feelings at the time, and those that emanated from him—there is, according to Stéphane Mallarmé (1842–1898), "a central purity" that could even be described as "religious," and that turns this painting into a sort of Byzantine icon. An Annunciation that reveals the spirituality of the painter, *The Conversation* is, in fact, a symbol of Matisse's art.

Cubism, Cubist

Although initiated by Cézanne's* *The Three Bathers*, the painting that so inspired Matisse, Cubism was actually born with the famous painting by Picasso,* created in 1907, entitled *Les Demoiselles d'Avignon*. The movement gained momentum in 1909. The Cézanne painting suggests volumes through geometric shapes, and there is an absence of unity in the representation and treatment of space. Picasso introduced a new way of painting motifs through divergent perspectives and the enhancement of the two-dimensional surface of the canvas. This consciousness of the mobility of figures and objects also resulted from the work of physicist Albert Einstein, according to whose theories space was the result of the relationships between various bodies. Matisse's portraits* of the period are indicative of his developing style and are no longer presented "in" a previously created space but "on" a totally deconstructed space.

Mallarmé (1842–1898) loved to explain Cubism as "A proposition of place.... These are dreams fulfilled solely through looking and feeling" The little cubes that Braque (1882–1963) juxtaposed in order to create his landscapes are a good illustration of this feeling of painting as being the desire to gain access to an esthetic purity of shape. It was the phrase "*bizarreries cubiques*" ["cubic weirdnesses"], used by Louis Vauxcelles in 1909 to describe the works of Braque, that gave Cubism its name. From 1911, this radical movement adopted the principal of pyramidal

composition and developed tactile brushstrokes. Its language of plasticity was also enhanced by applying stenciled lettering and numbering to the paintings. In 1912, paper was cut out and glued to the paintings, reintroducing color, which had hitherto been abandoned. The representations became less and less realistic and tended toward abstraction. Gris (1887–1927) became a Cubist in 1911; the movement's theorists were

Gleizes (1881–1953) and Metzinger (1883–1956). After 1912, Cubism, which had been the origin of most of the abstract trends, experienced a diversification of form.

Although Matisse, with his *Blue Nude, Souvenir of Biskra,** was a Cubist in his early years as a painter, he developed his own style of Cubism, in which geometry was sometimes combined with fantasy. "A difficult turning point for me was the period when

Cubism was triumphant. I was almost the only one not to participate in the experiments being conducted by the others. Of course, Cubism interested me, but it did not speak to my deeply sensual nature," explained Matisse. Matisse was depressed by black and gray, but the rigidity of the angles in *The Dining Table,** painted in 1915, are evidence of the well-meaning concessions to Cubism made by the artist.

Still Life based on *La Desserte* by Jan Davidsz de Heem, 1915. Oil on canvas, 5ft. 10.9 in. x 7 ft. 3 in. (180.2 x 220.8 cm). Private collection.

■ DANCE, THE

I n 1909, Sergei Shchukin, a fervent admirer and great collector* of the works of Matisse, commissioned a decorative panel on the theme of dance for his mansion in Moscow. Matisse had watched with delight the traditional dances of the fisherfolk of Collioure; he loved dance because it expressed life and rhythm, and it would provide him with endless inspiration. In 1960, Matisse explained to Jean Charbonnier how he had found inspiration for his dance themes. "When I had to compose a dance for Moscow, I simply visited the Moulin de la Galette on Sunday afternoon. I watched the dancers. I paid special attention to the farandole.... When I got home, I composed my dance on a surface of four meters, singing the same tune that I had heard at the Moulin de la Galette, so that the whole composition and all the dancers were together, dancing to the same rhythm." In less than two days, the artist had supplied the preparatory watercolor that finally convinced the Russian purchaser, and had offered him an initial version of the subject, one that was extremely lively and which he entitled *The Dance I*. It is currently in the New York Museum of Modern Art (MoMA). In its economy of color—the blue of the sky, the pink of the bodies, the green of the hill—this work perfectly embodies the feeling conveyed by the painting, that is, a call to contemplation. Some time later, Matisse painted a second, more finished, version, the result of his studies of volume. *The Dance*, purchased by Shchukin in 1910, is now in the Hermitage Museum in St. Petersburg. Both compositions are structured by the bodies of the dancers, and draw upon their dynamism in the oval shape created by their bodies; but the second version, in which the blue of the sky clashes with the green of the hill and the vermilion of the bodies, provokes a sort of

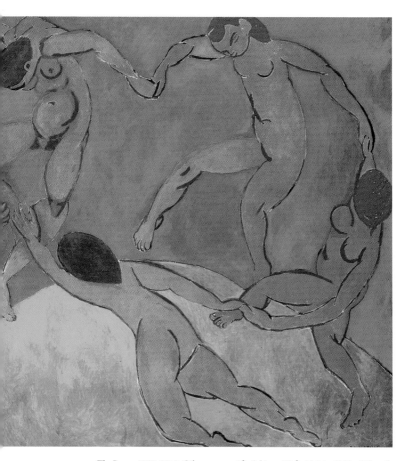

The Dance, 1909–1910. Oil on canvas, 8ft. 6.4 in. x 12 ft. 10.1 in. (260 x 391 cm).
Hermitage Museum, St. Petersburg.

astonishment, echo of the intensity that is at work here. In fact, Matisse had been preoccupied with the theme of dance for several years previously. Transposed onto a monumental scale, this circle of dancers almost literally repeats the central theme of La *Joie de vivre** painted in 1906 and sculpted in wood in 1907. The French dance known as the farandole is a symbol of the Golden Age, dominated by worship of the sun, and embodying in its ecstatic violence Matisse's true religion—happiness. Pierre Schneider claims that Matisse was the first artist to use this metonymic process whereby, in creating an equivalent and on drawing closer to it, sanctity can draw its mysterious veil over a canvas. "God manifests himself in violence, we are seized brutally by him, although for Matisse his name is Happiness, and the virtues that he attributes to him are 'serenity,' 'repose,' and 'appeasement.'" This sanctification of reality, leading to ecstasy, is echoed throughout all of Matisse's subsequent work, and especially in this painting's counterpart, *The Music.**

■ Dealers

Berthe Weill became interested in Matisse in 1901. She was thirty-six years old and eager to become an art dealer. She cared nothing for money—a fact that caused her to quarrel with a number of artists—but adored her new career and had the gift of discovering future great modern artists, such as Matisse and Picasso.* In 1902, she organized her third exhibition of contemporary artists, including Matisse and Marquet.* She sold her first Matisse, a still-life,* in the following year, and then held regular exhibitions of the painter's work. She became a leading light in the Parisian avant-garde. In her gallery on the Rue Laffitte, Gertrude and Leo Stein and the wealthy Russian collector Sergei Ivanovitch Shchukin discovered Matisse's work. However, it was the famous dealer, Ambroise Vollard, whose gallery was only yards away, who gave Matisse his first one-man show in 1904, though only after much hesitation. Although Vollard was in a position to make the artist better known, he spent more on the work of Cézanne* or on that of young unknowns who recommended Matisse to him.

■ DEBUTS
Entry into the Salons

It was not until Spring 1895, five years after he had begun studying at the École des Beaux-Arts in Paris, that Matisse succeeded in passing the entrance exam, but the jury of the official Salon continued to reject his work. After the great disappointment suffered by Gustave Moreau's* favorite student, Georges Rouault,* who failed to win the Rome Prize, Moreau placed all his hopes in Matisse. In early 1896, Moreau visited Matisse's studio on the Quai Saint-Michel to choose paintings suitable for exhibition at the Salon de la Société Nationale des Beaux-Arts. This institution was created in the early 1890s by Puvis de Chavannes* (1824–1898), to express his resentment at the overweening powers of his rival, William Bouguereau (1825–1905). It was a dissident exhibition whose selection criteria were far less rigid than the official Salon's. Matisse was invited to exhibit a dozen or so canvases every year from then on. The year had started well for the young painter, who had sold several of his paintings to the French government, including *The Reader*, which encouraged some members of his family to commission work from him. Five years after his ignominious departure from his home town, Bohain-en-Vermandois could once again be proud of their native son, who was finally gaining recognition for his work. Encouraged by his close ties with other young painters such as Simon Bussy (1870–1954) and Henri Evenepoel (1872–1899), the long years of study, so full of doubt and poverty, appeared finally to be behind him. He now wanted to break free of the rules of academic painting, and began to animate his still-life* work by adding the delicate presence of Camille,* as well as working once again on landscapes.

He had more confidence in Picasso, who produced the famous Cubist portrait of the dealer. In March, 1906, Eugène Druet, who had opened his gallery two years earlier, organized Matisse's second one-man show, a retrospective consisting of fifty-five works. Matisse was then noticed by Félix Fénéon (1861–1944), who had become head of the contemporary department of the prestigious Bernheim-Jeune Gallery. In 1908, the gallery signed a contract with Matisse, linking Fénéon with Matisse for the future.

Félix Fénéon,
1861–1944.

Gustave Moreau's studio
at the School of Fine Arts, c.1894.
Archives of Contemporary Arts,
Musées royaux des beaux-arts, Brussels.

▪ Decorative Figure on an Ornamental Background

Matisse's acute observation of the sculptures* of Michelangelo (1475–1564) resulted after 1918 in a series of reclining nudes, who from 1922 were brilliantly transformed into sensual, languorous odalisques such as the *Odalisque in Red Culottes*.* After 1924, he painted a few naked torsos, legs were bent, and nude bodies were placed in a space that still flirted with reality. In *Decorative Figure on an Ornamental Background*, Matisse tried to break away from the theatricality of their realism and introduce the nude more or less comfortably into his paintings. His worship of decoration, so forcefully stated in the 1907 version of *Harmony in Red—The Red Dining Table*,* re-emerged with such conviction that it became violent and almost menacing. Set in a space in which the third dimension is deliberately truncated by an absence of verticals and confusion in the depth, a nude woman is seated on the ground on a floor covered with carpets. The walls, carpets, and space are all covered in patterns or miscellaneous objects. The nude is striking in the extreme simplification of the volumes, a contrast with this plethora of decoration. The wallpaper pattern appears to timidly echo the curves of the figure's palpable nudity. But in declaring the figure to be "decorative," Matisse insists on the fact that the nude figure will be the last to be featured in his three-dimensional pictorial space, before he dissolves his decorative scenes into the field of abstraction.

Decorative Figure on an Ornamental Background, 1925–1926. Oil on canvas, 4 ft. 3.2 in. x 3 ft. 2.6 in. (130 x 98 cm). Musée national d'art moderne, Paris.

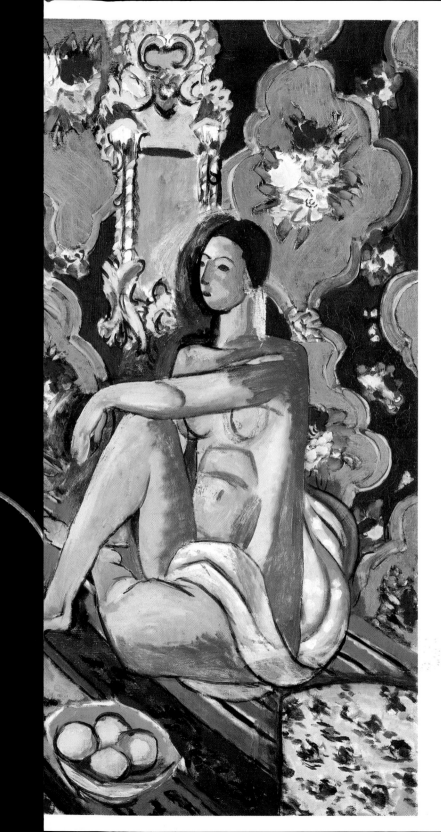

André Derain,
Collioure,
summer 1905.
Oil on canvas,
15.5 x 11.4 in.
(39.5 x 29 cm).
Tate Gallery,
London.

Derain, André

Henri Matisse and André Derain (1880–1954) were rivals in the daring work they produced while at the studio of Eugène Carrière (1849–1906), and soon became firm friends during the endless copying sessions, later sharing their moments of self-doubt and their artistic discoveries. Before becoming an early Fauvist* and producing some of the finest specimens of the movement's work, Derain, who still hesitated to break with tradition, had already proved his originality. He painted for a while at a studio in Chatou that he shared with Maurice de Vlaminck (1876–1958), whom he introduced to Matisse at the Van Gogh (1853–1890) retrospective held in 1901 at the Bernheim-Jeune gallery. Derain appears to have become an artist at an even later age than Van Gogh, perhaps as a result of the exhibition organized by Matisse himself at the Salon des Indépendants in 1905. This was also the year in which Derain made an easy break with Neo-Impressionism,* and when he went down to visit Matisse in Collioure. While there, he painted Matisse while Matisse was painting Madame Matisse in *The Green Stripe.** The colors used in that painting are just as violent but the observation is more naturalistic. Like Matisse, Derain visited London and was excited by the work of Turner (1775–1851) though he also

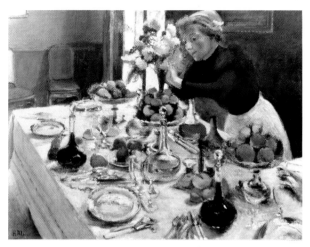

Dining Table (Preparations-Still Life), 1897. Oil on canvas, 3 ft. 3.4 in. x 4 ft. 3.6 in. (100 x 131 cm). Private collection.

greatly admired Primitive art. His works are carefully but always delicately composed, and those of his Fauve period were influenced by the work of Gauguin,* though the constructions are more flexible, the figures more distorted, and the curvilinear rhythm is systematized. Following his meeting with Picasso* in 1907, Derain had an argument with Matisse, and he embarked on his Cubist* phase before once again seeking inspiration from the past for his paintings. Yet he asked Matisse to take care of his wife, Alice, when he went away to fight on the front in 1914.

■ Dining Table, The

After endlessly copying the old masters, Matisse produced his first *Dining Table*, known as *The Dining Table*, which was painted in the spring of 1897 for an exhibition held by the Société Nationale des Beaux-Arts. The painting is an expression of his experimentation, and was intended to add to the success of his previous years, but was very badly received. The scene of the room with the set table was inspired by work of the Dutch painter Jan Davidsz de Heem (1606–1684). Matisse made studies for it from life in Brittany, and then reconstituted it in his studio,* illuminated by the colors of the spectrum. The composition is well ordered, and enlivened by Camille,* who is bent over the table as if in homage to the famous painting, *Bénédicité* by Chardin (1699–1779). The slightly disconnected brushstrokes make the canvas vibrate and reveal the strength and powerful brilliance of a Monet (1840–1926). Only Gustave Moreau* defended his pupil with conviction when faced with so much daring: "Let him do it, his carafes sit firmly on the table and I could hang my hat on their stoppers. That's the main thing." A few years later, Matisse explained the general incomprehension with which this work was greeted. "I worked as an Impressionist,* directly from nature, and then I sought concentration and a more intense expression, in the lines as well as in the color; so obviously, I had to sacrifice other values such as the material, the depth in space, and the richness of detail." Matisse's mastery of color and of observation in the tradition of Degas combined to make this work of art particularly revolutionary.

51

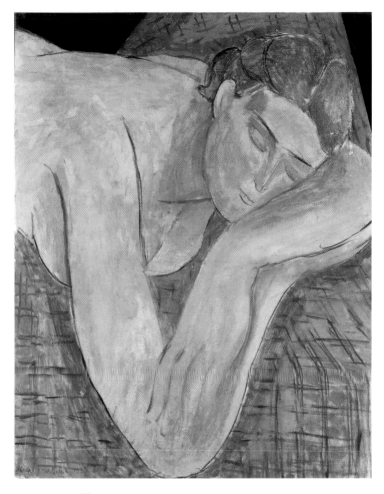

The Dream,
April–May 1935.
Oil on canvas,
31.9 x 25.6 in.
(81 x 65 cm).
Musée national
d'art moderne,
Paris.

■ Dream, The

As with *Pink Nude,** *The Dream* is striking by the monumentality it appears to have despite its modest dimensions: it is only 32 inches (81 cm) high and 26 inches (65 cm) wide. Yet there is a loss of reference points and more accentuated abstraction in this painting. The checkered fabric* covers almost all of the background, the lines are blurred, the contours are approximations. As in *The Bathers,** the painting reveals its entire history, Matisse's decisions, hesitation, and second thoughts. The close-up focuses not on the area of nudity but on the face of the woman deeply asleep. You can almost hear her breathing. She has become so huge that she overflows the frame and invites us to extend her body beyond the painting. Dissolving the pictorial space, her dream also escapes from the frame and extends into infinity. The dream has enveloped the painter, who has created his own dream within the space of the picture. In *Pink Nude*, the body dissolves definitively into a sign and the

drawing takes its orders from the painting. The same is true of the 1940 version of *The Dream*, in which Matisse ceases to depict a movie of his feelings. From now on his work is dedicated to time. His sleeping woman is decorated with wavy lines, unlike *The Dream* of 1935, and by adopting an almost calligraphic expression it is one of the most beautiful examples of the simplicity instilled in his work by Matisse to render the image peaceful and welcoming. "This is a painting that took a year to create. Those who can only see the way in which I represented the hair and the embroidery on the shoulder will think I am joking, but you…you know!" he confided to Théodore Pallady.

■ Entrance and Minaret, Mosque in the Casbah

This scene at the entrance to the Casbah was painted during Matisse's second visit to Morocco.* It was designed as one of the parts of a triptych also consisting of *Landscape Seen through the Window* and the portrait of Zorah entitled *On the Terrace*. The brilliant yet delicate blue that is common to all three paintings, and that had already been used in *The Conversation*,* constructs the composition. The brilliant white of certain of its components has the effect of standing out from the canvas and accentuates the viewer's sense of disorientation. The gateway is an echo of Matisse's use of the window,* and as an arch framing the view, it draws us into the Casbah, while projecting us to an external landscape. Matisse thus translates with assurance his feeling of space, in which the foreground and background melt into the same perspective that glows in the light. *Entrance and Minaret, Mosque in the Casbah* was based on a initial sketch—less daring and less contrasted—that he made on the first day of his visit. The work shows evidence of repainting by the artist. By going to the crux of the matter, Matisse finally answers the question raised by Fauvism*: by using pure color, how can one retain the readability of objects? As Pierre Schneider explains, in Morocco Matisse discovered that objects have the inconsistency and precision of clouds. The way that certain outlines are emphasized appears to be an arbitrary choice that hints at abstraction, although it also introduces doubt. Has the pictorial reality encroached upon the physical reality, or is the opposite the case ?

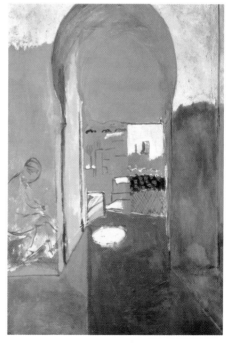

Entrance and Minaret, Mosque in the Casbah, 1912. Oil on canvas, 3 ft. 9.3 in. x 31.5 in. (115 x 80 cm). Moscow, Pushkin Museum.

■ EXPERIMENTATION

atisse's first trip to Brittany opened up different horizons, providing a contrast to the flatness of Picardy. Matisse remained faithful to his first love of Chardin (1699–1779) whose palette reflected the grayish tones of Flanders. In 1896, during his second stay in Belle-Île, he copied two poems from Les Fleurs du mal by Baudelaire (1821–1867) in order to help him remember them, and a few years later, they inspired the painting entitled Luxe, calme et volupté.* The collection is a hymn of praise to the painters who shaped the history of art, such as Leonardo da Vinci (1452–1519), Rembrandt (1606–1669), and Goya (1746–1828). The poem Les Phares [The Lighthouses] is particularly in tune with the classic landscape of Matisse's apprenticeship,* while L'Idéal shows the same wariness of "official" art. During this summer, Matisse met John Russell* and, being impressed with both his character and his painting, he was encouraged to experiment with different themes, such as the open door, which then led him to the theme of the window.* Guided by an Impressionist* attitude to light, he continued to paint landscapes and still life.* However, Matisse's new style was greeted with little enthusiasm, and The Dining Table,* exhibited at the 1897 Salon, only found favor with Gustave Moreau.* His obstinate determination to continue along this path aroused general incomprehension, and his canvases became unsaleable. He spent a third summer at Belle-Île, but this did nothing to solve the problem and he began to suffer from insomnia. A subsequent stay in Corsica aroused Matisse's enthusiasm when he experienced the light of the Mediterranean for the first time. He and his wife, Amélie,* took a house in the Bay of Ajaccio, which soon became an ideal retreat for him. He loved the simplicity of life in Corsica and the exotic vegetation. The palms, fig trees, and other shrubs were redolent of the perfumes of the Orient* that fired his imagination. Corsica was more than a place in which to work, it offered him a perfect escape and freed his creative instinct. This was the path toward the extolling of color that led him to embrace Fauvism* a few years later. On the other hand, most of the canvases that he produced during his stay depict his bedroom, his studio,* or are still-life* paintings, and are always influenced by the art of Monet (1840–1926). Finding himself in ever-greater financial difficulty, in 1900, Matisse sought employment

Belle-Île, 1896–1897. Oil on canvas. Musée des Beaux-Arts, Bordeaux.

at the Académie Carrière. By working as a student in charge of the common funds, he was able to attend courses for free. Encouraged by the liberalism of Eugène Carrière (1849–1906) and his innovating teaching methods, he experimented with variations on color and distortion of all types. It was during this period that he copied sculptures* by Barye (1796–1875), before meeting Bourdelle (1861–1929). Matisse's various experiments culminated with the work exhibited at the Salon des Indépendants in 1901, where he was the only artist to use pure color. His participation in this new and fashionable exhibition, and his frequent shows at the Berthe Weill gallery caused him gradually to become the leading light in the new generation of painters. At the same time, he continued to labor to find a plastic equivalent in light to that of the harmony of color, but family problems hampered his efforts.

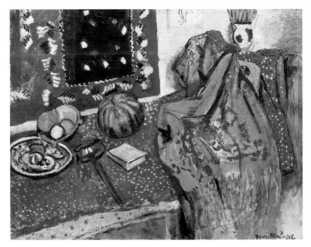

The Red Carpets,
1906.
Oil on canvas,
3ft. x 3 ft. 9.7 in.
(90 x 116 cm).
Musée de Peinture
et de Sculpture,
Grenoble.

■ Fabric

The inventiveness of the weavers of Bohain-en-Vermandois, whose industry expanded rapidly after the Franco-Prussian war of 1870, thanks to the rise of the Paris* fashion houses, was greatly admired by Matisse from his early youth. He loved the brocaded velvets, the elegance of the embroidered silks, and the softness of the furry cashmere woolens. The new generation of weavers who supplied the big department stores such as La Cour Batave, or the great couturiers like Chanel, had inherited an ancient tradition of northern France, that of the Flemish weavers, which was revived in the early twentieth century through the creative power of men like Matisse's great-grandfather. Matisse loved the industry and noise of the mills, and would do so throughout his life. The textile industry fed his imagination and sharpened the love of decoration that he inherited from his mother Anna Matisse.* Shortly after he moved to Paris, unable to give up this contact with materials that was almost carnal, Matisse recreated the colorful, tactile world of his childhood* by decorating his studio* with expensive fabrics.

He was proud of the Bohain weavers who wanted to create luxury that was "a wealth above money but affordable by all," and he introduced patterned fabrics into his earliest still-life* paintings. He later covered the walls and floor of his studios with Oriental carpets bought at a shop in Port-Royal. Although they appear to be mere decorations, the multicolored wall hangings or *Red Carpets* often have the status of a structural element in the paintings. Until 1930, the juxtapositions of patterns were a subtle ploy to create perspective, a compromise between the planar space of the carpet and the three-dimensional aspect of the traditional pictorial space. By making the decorative patterns the very subject of his paintings, Matisse was highlighting the problem that preoccupied him throughout his life—the materiality of painting. Then, gradually simplifying his work and reducing the decorative covering of his art to the basics, he gave his work the power to fuse image and material. Thus in *The Romanian Blouse,* painted in 1940, the red of the embroidery and weave of the canvas are combined into a single fabric.

■ FAUVISM, FAUVIST
An Orgy of Pure Tones

Guided by the new experience of light resulting from his stay in Collioure in the company of Derain,* Matisse launched himself wholeheartedly into a paean of praise for pure color. He continued to be loyal to the Divisionism of Paul Signac* (1863–1935), still employing small brushstrokes, although he now used them to balance the canvas, as a musician would allow notes to produce the harmony of a chord. Painting was no longer merely the result of the capturing of light through color, but had become the vehicle that was used to produce it. In other words, the painting was light. Colors became its constitutive and structural elements, functioning as vectors of energy that enable us to recreate our own images. The canvas becomes a meeting-point for our own vision and that of the painter. When Matisse returned from Collioure, he was faced with another problem: how to transpose the power of his chromatic construction into a portrait.* *The Woman in a Hat** and *The Green Stripe,** modeled by Amélie,* became the portraits that were symptomatic of the new esthetic. Other Beaux-Arts students, such as Marquet,* Camoin,* Manguin,* and Derain—the "Matisses," as the painter Maurice Denis (1870–1943) nicknamed them—exhibited with Matisse at the Salon d'Automne in 1905. Enraged by the violence of the colors and the stylization of shapes, the critic Louis Vauxcelles wrote in the supplement to *Gil Blas* on October 17, on the subject of two small sculptures by Albert Marquet that had been submitted to the Salon, "The candor of these busts is surprising in midst of an orgy of pure tones; it is Donatello among the wild beasts […]." His use of the word for "wild beasts," "fauves" in French, gave the group their name. Fauvism was adopted to designate the group of painters who were the heirs of Impressionism,* but who wanted to find a balance between expression and decoration. They favored the use of pure color, and wanted to return to the pictorial resources that were to be considered for their own sake. Maurice de Vlaminck (1876–1958), who met Matisse in 1901, was a member of this group, as were Raoul Dufy (1877–1953) and Othon Friesz (1879–1949), who discovered Matisse's work in the same year. As for Matisse, he constantly sought release from Impressionism in order to create his own combinations.

*La Joie de vivre** is a real manifesto of the Fauvist experience; he painted it in 1905–1906 for the 1906 exhibition at the Salon des Indépendants. It was also his way of leaving Neo-Impressionism* behind.

Cover of the Salon d'Automne catalog, 1905.

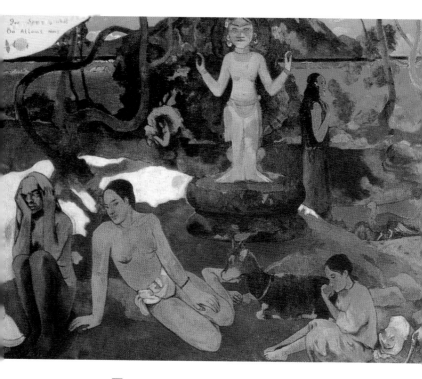

■ Gauguin, Paul

Paul Gauguin (1848–1903) was born in Paris* but spent part of his childhood in Lima, Peru, returning to France at the age of nine to continue studying until the age of eighteen. After enlisting in the French navy for three years, he was hired by a bank, but began to take a strong interest in painting. He studied the works of the great nineteenth-century masters, such as Delacroix (1798–1863) and Courbet (1819–1877), but it was really through his contact with Pissarro* that he did his apprenticeship, and he first exhibited his work with Pissarro* in 1879. In 1883, Gauguin decided to abandon his career in banking and devote himself entirely to his passion.

In 1886, he embarked on a series of trips to Brittany, but it was when he traveled to Martinique that he discovered pure color. He consequently adopted a principle based on the complementary nature of colors, a theory dear to the heart of the Impressionists,* placing yellow next to blue, for example, instead of using orange. Gradually his colored brushstrokes turned into large patches of color, a style that other artists, including Matisse, also adopted in the early twentieth century. Rumors of his involvement in the macabre episode during which Van Gogh lost an ear (1853–1890) in the Midi led him to lose hope in starting a new school of painting far from the academic style of the École des Beaux-Arts. Leaving his wife and children behind, he set sail for Tahiti in 1891, in search of the ideal place in

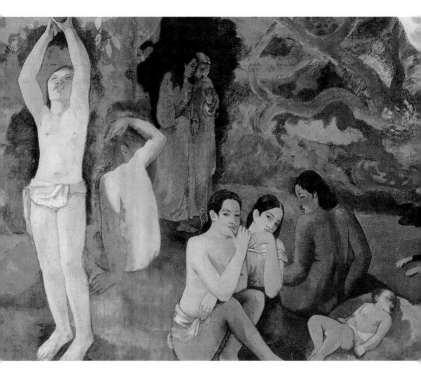

which to work. Upon returning to Paris, the incantatory style of his exotic paintings was greeted with derision, and caused him to exile himself permanently.

Gauguin's art is close to esthetic symbolism in its lines, despite the fact that he ridiculed that style. It is the mirror of an increasing anguish that expresses his loneliness and his financial difficulties. After a failed attempt at suicide that caused him to become even more introspective, in 1901 he took refuge on Hiva-Hoa, a little island in the Marquesas where he died, still the subject of incomprehension and general indifference. Despite this treatment, Gauguin was just as influential a figure in modern art as Cézanne* or Van Gogh. While the Nabis soon recognized their debt to him, Degas (1834–1917) was the only Impressionist to appreciate his work and share his taste for rhythm and the harmony of color. Matisse rejected Gauguin's non-conformist theories as long as he remained under the spell of his classical training. But when he met the painter Daniel de Monfreid (1856–1929) at Collioure in 1905, a man who had correspondended regularly with Gaugin and been his agent, he realized the emotional power of his work as a colorist and began to understand the spiritual dimension of his painting. While assimilating the same desire for decoration without in any way seeking to imitate him, Matisse found in Gauguin's art the means by which he could release himself from the Neo-Impressionist* straitjacket.

Paul Gauguin, *Where do We Come From? What Are We? Where Are We Going To?*, 1897. Oil on canvas, 4 ft. 6.7 in. x 12 ft. 3.5 in. (139 x 374.5 cm). Museum of Fine Arts, Boston.

◼ Goldfish

The goldfish theme first emerged in 1910 in a still life.* Like the window* and the studio,* the subject occupies an important place in Matisse's work. *The Goldfish*, the still life he painted in 1911, draws attention with the intensity of the coloring and dynamism of shape. Suspended in the transparency of the water, they balance the vermilion in a state of weightlessness. They are found again on canvases painted in 1912. In *The Arab Café*,* where they are associated with a peaceful atmosphere, they explicitly represent well-being and happiness, perhaps mindful of the French expression "to be happy as a fish in water." Pierre Schneider also believes that goldfish are symbolic of a golden age: "not only due to their color, but also because they are objects of contemplation." *Interior with Goldfish*, painted in 1914, combines Matisse's favorite themes—goldfish, a window, and the studio—and the green plant leads the eye to the window, where we can look out at the view from the studio. Only two fish remain in the bowl, as if the third had escaped, released from its color as Matisse would find himself released toward the end of his life. The goldfish are suspended in the field of the painting as an object being contemplated by the painter.

Interior with Goldfish, spring 1914. Oil on canvas, 4 ft. 10 in. x 3 ft. 2.2 in. (147 x 97 cm). Musée national d'art moderne, Paris.

Blue Nude II,
1952. Gouache
on découpage
and pastels,
3 ft. 9.8 in.
x 32.3 in.
(116.2 x 81.9 cm).
Musée national
d'art moderne,
Paris.

■ GOUACHES DÉCOUPAGES
Cut-outs, the Paintings of Light

It was while creating The Merion Dance* that Matisse introduced the technique of gouache or paper cut-outs (découpage). He used the same technique to decorate the covers of the magazine *Verve,* published by his friend, Emmanuel Tériade. Tériade hoped to produce a publication devoted entirely to the work of Matisse. In 1943, the painter, confined to a wheelchair by his illness, produced the first gouaches découpages for *Jazz.* These are the incarnations of his thoughts and feelings, as well as of his suffering. The inspiration for this album came to him at night and consists of text by the artist and twenty cut-outs, but it was not published until September, 1947. Pursuing his love of decorative art, the technique of paper cut-outs provided Matisse with a new means of expression, a catalyst for all the techniques he had tried throughout his career. The use of scissors enabled him to cut into color as a sculptor cuts into stone, and to obtain a shape that creates a perfect combination between the line of the drawing and the color. Until the end of his life, Matisse was able to produce large compositions, merely by cutting out painted shapes, and these are characterized by an exceptional luminosity. Guided by his memories, between 1948 and 1952 he undertook two series of cosmic inspiration entitled *Oceania* and *Polynesia.* But it was his last gouaches that say the most about the extent of his imagination. Carved out of azure blue, his famous *Blue Nudes* project the viewer into infinity and confirm to us, as Georges Duthuit puts it so well, that Matisse is "the cutter of light."

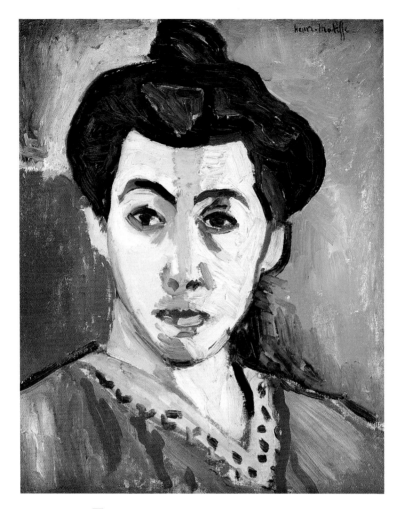

Portrait of Madame Matisse, also known as The Green Stripe, 1905. Oil on canvas, 16 x 12.8 in. (40.5 x 32.5 cm). Statens Museum for Kunst, Copenhagen.

■ Green Stripe, The (Portrait of Madame Matisse)

The absolute frontality of the pose of Madame Matisse in the portrait known as *The Green Stripe*, which anchors the model to the canvas, is an allusion to the classical portraits that line the walls of the Louvre. Yet there is a whiff of surrealism that escapes from the apparent solemnity of this second Fauvist* portrait by Matisse. The green stripe divides her face in half, running from the forehead down the line of the nose, and in its improbable reality it is the place at which the light merges into shadow. It reconciles the dissonances and provides a focus for the composition. The Pointillist brushstrokes of the canvases painted at Saint-Tropez are here replaced by large areas of flat color that rigidly structure the surrounding space. The surface of the canvas no longer looks like a harmonious quest for small, juxtaposed brushstrokes, but

like an assembly of separate parts of equal value. The shadows have been erased, and colors have been substituted for them. The surprise comes from the dazzling, almost violent display of colors, borrowed from Van Gogh (1853–1890), which sometimes contrasts with the softness of the transparent areas. As in *Woman in a Hat*,* *The Green Stripe* is for Matisse a realization of the existence of a world of color, but the atmosphere is calmer here. From being a representation, Madame Matisse has moved on to become an image. "I replied to someone who said that I did not see women as I represented them, 'If I saw similar ones in the street, I would run away in horror.' Above all, I am not creating a woman, I am producing a painting," explained Matisse. As a painting rather than a portrait, *The Green Stripe* is a revival of the decorative icon.

■ Harmony in Red—The Red Dining Table

The "Fauvist*" version of *The Dining Table*,* painted in 1897, was *Harmony in Red— The Red Dining Table*. The 1908 interpretation has the same intimacy as the earlier picture, though simplified, and places the emphasis on the intensity of the color. Although the two compositions are similar, the focus on details and objects in the earlier version is displaced in the latter by the curlicues decorating the wall and the tablecloth. Naturalism has thus given way to violent contrasts and the abstraction of forms. At the same time, the space has lost some of its depth and tends to become two-dimensional, a trend that can be seen elsewhere in the artist's work of this period. Three-dimensionality, inherent in realism, was restored in the oval ring of dancers in *The Dance*,* yet it is almost completely

Harmony in Red, The Red Dining Table, 1908. Oil on canvas, 5ft. 10.9 in. x 7 ft. 2.7 in. (180 x 220 cm). Hermitage Museum, St. Petersburg.

absent from *The Music*.* In *Harmony in Red*, the artist threatens to sacrifice three-dimensionality in order to justify the unreal presence of the red. Representing wallpaper and tablecloth, the red shading with its blue and green designs could cover in part the canvas and also satisfy Matisse's love of decoration. The possessive hold that color has on the canvas would continue to develop until, in an ultimate gesture, the artist would be pushed to cut out his paintings as if he were cutting fabric.* At the same time, *Harmony in Red—The Red Dining Table* retains the concept of converging lines created by the perspective, but they are lightly traced, accentuating the abstract nature of the painting. There is a constant interaction between expression and suggestion, realism and abstraction. The canvas is a series of contradictions, and its incandescence maintains the unity of the series of shapes placed on it by Matisse.

■ Impressionism, Impressionist

A new perception of painting was born among a group of artists who were pilloried by the critics and who wanted to break with the academic precepts of the "official" art of the nineteenth century. They began by creating the Salon des Refusés in 1863, where they could exhibit the paintings that had been rejected by the academicians. Their desire to create a less scholastic and more sensual style was given a focus when, in 1866, a popular art form was discovered that was full of promise—Japanese art. Japanese painters practiced a different form of realism, which was

based on the ephemeral effects of light. From now on, it was no longer a matter of painting contrasts, but rather of restoring the various colors that comprised the spectrum. The capturing of a reflection in order to release oneself from established pictorial constraints was the motto of the Impressionist wave of painters who first exhibited their work in 1874. The movement's name derived from Monet's famous canvas

entitled *Impression: Rising Sun.* By wanting to convey an "impression," the Impressionists were determined to put the emphasis on the concept of subjectivity as well as on the notion of speed (an "impression," in technical terms, is the first layer of an oil painting). Monet (1840–1926), Renoir (1841–1919), and Pissarro,* who serve as witnesses to their age, usually worked in the open air and were delighted to illustrate how the Parisian middle class took their leisure in country pursuits, recording their activities just as they "felt" them. In Brittany, Matisse became initiated into Impressionist art. Through Impressionism, he discovered the modernity of the problems they were attempting to solve. *The Dining Room** is an example of his mastery of the subject and places Matisse right in the tradition of the colorists.

Claude Monet, *Impression, Rising Sun*, 1873. Oil on canvas, 18.7 x 24.6 in. (48 x 63 cm). Musée Marmottan, Paris.

◼ JOIE DE VIVRE, LA

Painted upon his return from Collioure for the 1906 Salon des Indépendants, *La Joie de vivre*, which was greeted with general hilarity at the time, represents Matisse's final break with Impressionism* and Neo-Impressionism.* It took the artist five months to produce this very ambitious canvas, which heralded the Matisse vision of the world. As in the case of *Luxe, calme et volupté*,* the scene appears to depict music and dancing in a country setting, and borrows its vocabulary from Symbolism.* In fact, the classical, pastoral theme enabled Matisse to reintroduce the human figure into the countryside and seek the plastic equivalence of its movement. Thus, in a final homage to Puvis de Chavannes* (1824–1898), the thickly outlined curves that animate the figures and landscape are part of a rhythmical dialectic of the composition and give them a musical beat.

The realism that Matisse was taught by Courbet (1819–1877), Manet (1832–1883), and Cézanne* is substituted for a linearity of drawing that reinforces the decorative aspect, inherited from the purity of carefully harmonized tones. By replacing shape with a sign, Matisse overturns the codes of painting and introduces his

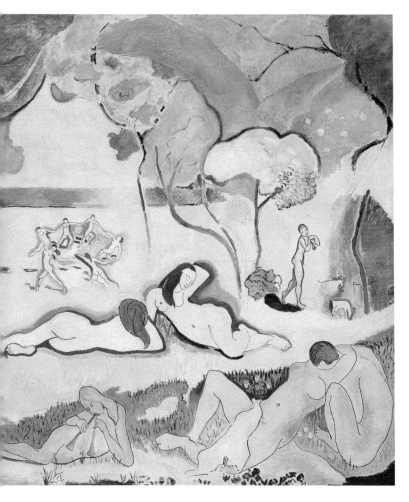

La Joie de vivre, 1905–1906. Oil on canvas, 5 ft. 8.9 in. x 8 ft. (175 x 241 cm).
The Barnes Foundation, Merion, Pennsylvania.

own language that finds its fulfillment in the cut-outs, the gouaches découpages.* Transposed into a halcyon atmosphere, the principles of which he had originally used in his landscapes of Collioure, the artist plays with reality like an abstraction, and plunges the viewer right into the scene that he is contemplating. It is an Arcadian allegory that also has something of the eclectic; yet it opens onto a new world in which women, in the voluptuousness of their nudity, express the "sentimental moment" of the painter. For Pierre Schneider, "After several centuries of divorce, *La Joie de vivre* restores the links between European art and sanctity, that is to say, with its origins." This esthetic of happiness, while still a prisoner of its iconographic meaning, would liberate itself completely by invading the total space of *The Dance** with its subject-matter.

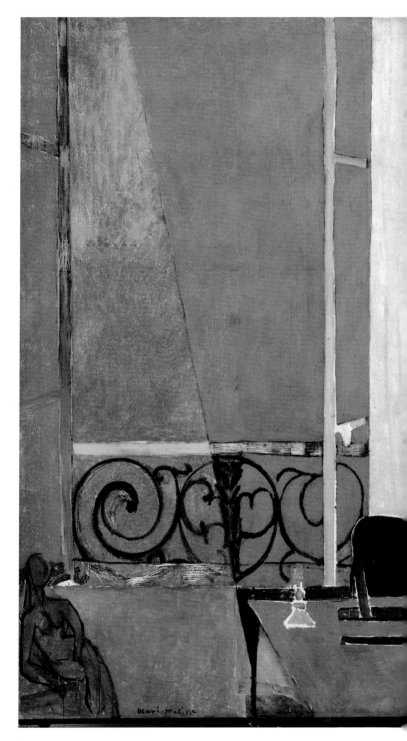

■ Lessons, The

In the same way that *The Painter and his Model*,* could have been entitled "The Painting Lesson," *The Piano Lesson* and *The Music Lesson* are actually family portraits,* painted by the artist in 1916 and 1917, after the long period during which he spent much time abroad. If there is a lesson in them, it is in their plastic expression and in the virtuosity that Matisse displays in them to express the values he attaches to painting. In *The Piano Lesson,* a composition of great mastery, in which the metronome provides the rhythm just as it provides the rhythm for playing the piano, the structural diagonals on the left-hand side are echoed in the face of his son Pierre,* and are an explicit declaration of that which guides the painter: balance and measurement. The artist seems to have managed to liberate himself from the Cubism* of his earlier years and to transform the painting into a delicate abstraction, a harmonious simplicity, in which the use of gray plays a truly unifying role. Matisse inflicted these lessons on Pierre—who eventually became one of the greatest modern-art dealers* of his time—in the hope that he might become a concert pianist. By immortalizing them on canvas and accentuating the instrumental nature of the painted scene, the artist seems to be highlighting the need to learn and study. The piano lesson could easily have become an art lesson, for if the window* appears to open onto an empty space, the space is well painted and simply brings us back to the gesture of the painter. In *The Music Lesson*, Matisse

The Piano Lesson, 1916. Oil on canvas, 8 x 7 ft. (245.1 x 212.7 cm). The Museum of Modern Art, New York.

depicted his whole family, as if to compensate for the years of separation from them, which he explains as responding to his "aristocratic egotism." This time, the window opens onto a garden that no longer shuts in the space but into which he has introduced an important element in the development of his work, the sculpture* of the *Reclining Nude I (Aurora)*, the original model for *Blue Nude, Souvenir of Biskra.** The feeling that this painting emits is one of serenity and peace. The painter's family seems to be surrounded by happiness. Matisse is no longer far away; he has rested his violin on the piano.

Luxe I, Collioure, summer 1907. Oil on canvas, 6 ft. 10.7 in. x 4ft. 6.3 in. (210 x 138 cm). Musée national d'art moderne, Paris.

■ Luxe, calme et volupté

The picture was painted in Matisse's studio on the Quai Saint-Michel in 1904 and is a result of various studies from his stay at SaintTropez. It contains

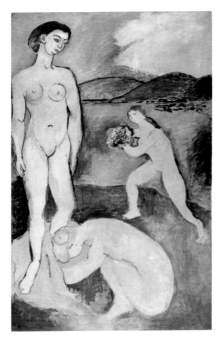

many of the fundamentals of his work. The painting is a continuation of the theme of the Golden Age, revived by Puvis de Chavannes* (1824–1898), and reveals a significant stage in Matisse's Neo-Impressionism.* It is inspired by the "setting suns," the "canals," and the "warm light" of Baudelaire's (1821–1867) *Invitation to Travel.* Matisse transforms the Bay of Saint-Tropez into an idyllic landscape animated with the figures of bathers of Ingres-like proportions. He leads us into his reinvented paradise, just as Manet (1832–1883) invites us to his *Luncheon on the Grass*, convinced that:

"Here, everything is order and beauty. Luxury, calm, and voluptuousness."

Luxe, calme et volupté, fall–winter 1904. Oil on canvas, 3 ft. 2.8 in. x 3 ft. 10.7 in. (98.5 x 118.5 cm). Musée d'Orsay, Paris.

The principle of the Divisionist brushstroke, inherited from Neo-Impressionism* and known to Matisse since the end of the 1890s, reached its zenith in this painting. Thanks to the influence of Signac* (1863–1935), Matisse produced systematically and rigorously fragmented patches of color in this painting, but "the pure colors of the rainbow," which obey a carefully studied construction, have been juxtaposed one by one on the surface of the canvas, illuminating every part of it. Constantly desirous of creating a new relationship with art, the surprisingly decorative air of the canvas is like the plastic equivalent of the illustrated theme. The deliberately slanted strokes, devoid of any spontaneity, are confined to illusionism. *Luxe, calme et volupté* thus appears to be a utopian view of the present, in which all the moving elements that might enable the viewer to relive a lost happiness have been collected by the artist. At the heart of this eulogy there is a landscape decor, a reunited family, and an allusion to classical mythology; these themes would soon run through Matisse's entire output.

■ Luxe I, Le

After *Blue Nude, Souvenir of Biskra,** in the spirit of the Primitivism* that was popular at the time, Matisse decided to create a painting on a monumental scale. The result was

Le Luxe I. The composition is similar to that of Cézanne's* *The Three Bathers* and is also an interpretation of his *Lovesick Shepherd*. The painting is a delightful evocation of the Three Graces dancing in a ring, but develops a more complex rhythm. In the foreground, a maidservant crouches at the foot of a Venus, while a third woman in the background bends forward to offer the goddess a bouquet. The scene is an idyll in a landscape, in a simplified style borrowed from Puvis de Chavannes* (1824–1898). The setting is, in fact, the Gulf of Saint-Tropez, where Matisse spent the summer of 1904. The broken outlines emphasize the separateness of the movements, but there is also an arabesque of the type favored by Gauguin,* giving the painting its decorative value. By shattering all

Portrait of Madame Matisse, 1912–1913. Oil on canvas, 4 ft. 9.1 in. x 3 ft. 2.2 in. (145 x 97 cm). Hermitage Museum, St. Petersburg.

continuity in the images, Matisse was already seeking to make the viewer concentrate on the materiality of the painting. Although there are a few signs that his Impressionism* and Fauvism* persisted, especially in the treatment of the background colors, he has abandoned the Neo-Impressionist* technique and palette of *Luxe, calme et volupté** by adopting a cooler tonal harmony. Matisse attempted to transcend the sources of inspiration used in his *La Joie de vivre,** while taking elements from it and transposing them into a setting so gigantic that it is given a certain sanctity and draws the viewer into the spirituality of its pictorial space.

■ Madame Matisse

Until he moved to Nice, Matisse liked to use the members of his family as his models. From the start of their marriage, Amélie* would sit for her husband. She was extraordinarily patient throughout the period of his experimentation,* and supported him in his break with the rule of the academicians, going along with his endeavors. As the model for *Le Goûter*, painted in Saint-Tropez after a walk that was designed to calm him down after his quarrel with Paul Signac* (1863–1935), Madame Matisse delicately embodies all that Matisse liked about the female form. The theme of *Le Goûter* is repeated in *Luxe, calme et volupté,** the painter making his wife into a participating element in the founding myth. She is his co-conspirator in *The Woman in a Hat,** and accompanies Matisse in his feeling for color, becoming a "decorative" element in *The Green*

*Stripe.** She was also the model* for the first nudes he produced in the open air in 1906; she represented the range of his imagination. In 1913, the painter, inspired by the close-ness of the couple, completed one of the most touching por-traits* of her. *Madame Matisse*'s mask-like face emerges from the whiteness of her skin and black lines of her features, through a cool harmony of grays, greens, and blues. This schematic breakdown was a style adopted by Matisse when he returned from Morocco;* he would expand upon it in portraits* that were much more Cubist* in style. It does not detract from the likeness. Although her elegance is concealed by the hieratic pose, the way her head is inclined and the delicate wisp of orange scarf are enough to break the barrier between her and the viewer, and this makes her appear much more approachable and human.

Manguin, Henri

Matisse met Henri Manguin (1874–1949) while studying applied art; Manguin was then eighteen years old. He was a dandified Parisian, gifted and energetic. He very soon showed a talent for painting that enabled him to find a place in Gustave Moreau's* studio. Matisse found his extreme sen-sitivity, as well as the serenity he acquired after marriage, to be very likeable. As for many of his colleagues, the Cézanne* one-man show in 1895, followed by the Van Gogh (1853–1890) Retrospective held at the Bern-heim-Jeune Gallery in 1901, were both revelations for Man-guin. After the 1905 Salon des Indépendants, Manguin decided to visit Saint-Tropez.

Henri Manguin, 1905.

Matisse, on the other hand, chose to go to Collioure, but they wrote to each other regu-larly. Contact with the Mediterranean light gave Man-guin a new perception of color that not only better suited his sensibilities, but also gave shape to his emotions. He launched himself headlong into produc-ing bright, lively paintings in perfect harmony with the Fau-vism* movement that had been denounced by the critic, Louis Vauxcelles, at the 1905 Salon d'Automne. Preserving his own brand of sensuality, Manguin developed a style that was sometimes at the limits of exu-berance, but always carefully constructed. Leo and Gertrude Stein (1874–1946), themselves artists and art-lovers, forged close ties with Manguin. This brought them closer to other French artists, so it was Man-guin who introduced them to Matisse. They eventually bought his *La Joie de vivre.**

Marguerite

The birth of Marguerite on August 31, 1894, put the relationship between Matisse and Camille* on a firmer footing, at least for the time being. The artist acknowledged her as his daughter in February, 1897, but she was devastated by the separation of her parents. Alone with her mother, the young girl shared her disappointment and misery with her while impatiently awaiting the weekly visits from her father. Camille was so upset by her daughter's sadness and her own financial difficulties, that she agreed to hand her over to Amélie* when she was four years old. Marguerite developed a close relationship with her stepmother and became a valuable assistant, helping to run the studio and raising her two younger half-brothers. As someone who was brought up amid paintbrushes and tubes of color, she was naturally interested in painting, and Matisse paid her a lot of attention. The first portrait* of Marguerite shows her in her striped blue-and-white

Marguerite,
1915. Pencil,
8.6 x 6.8 in.
(21.9 x 17.2 cm).
Private collection.

Henri Matisse and Albert Marquet, c. 1908.

apron with her large "odalisque eyes" inherited from her mother. She also inherited a delicacy of feature, but she had the iron determination and immense courage of her father. She caught diphtheria in 1901, and this was followed by typhoid. Her brush with death made her even dearer to Matisse. As Camille had once done, she often posed for the artist and represented the ideal model* for both his paintings and his sculptures.* Yet her health remained delicate, giving the artist constant cause for concern. Fortunately, her importance within the family circle restored her self-confidence and she had a happy adolescence. She chose to marry the art historian, Georges Duthuit, in 1920. Like her mother, she worked for the Resistance in World War II and was imprisoned by the Vichy regime.

▇ Marquet, Albert

During the course of his apprenticeship* at the École des Arts Décoratifs, Matisse became friends with Albert Marquet (1875-1947). This helped them to overcome some of the hardships of the student life.

Marquet's character was the total opposite of Manguin's.* He was a loner, preoccupied with freedom, and particularly difficult to get to know. Matisse soon discovered the sensitivity of the young painter—and his extreme determination, which caused him, among other things, to take the École des Beaux-Arts entrance examination nine times. As for Marquet, he liked Matisse's free-and-easy nature and his vivid imagination, and agreed to paint alongside him. In fact, the lines and construction of *The Terrace at Saint-Tropez*, painted in 1904, owes more to Marquet than to Signac's* (1863–1935) Divisionism, which caused the latter to fly into a rage against Matisse. Marquet became a Fauvist,* and this was due more to his friendship with Matisse than to his style of painting, which was restrained and somber. For a time, he shared with Matisse and Manguin* the same art dealer,* Ambroise Vollard. In 1905, Marquet also discovered the south of France and was happy to begin painting in the open air. Even though he adopted the flat areas of color of

Gauguin* and the atmospheric light of the Impressionists,* his work is to be appreciated for the originality of the composition. His landscapes, dominated by grayish tones, have the thick outlines of Japanese paintings and calligraphy. His work has much in common with that of Manet (1832–1883), but for Matisse, Marquet would always be "our Hokusai."

Matisse, Anna and Émile

As the son and grandson of weavers, Émile Matisse (1841–1910), Henri's father, was brought up in the weaving tradition of northern France. He took a decisive step in becoming a clerk at La Cour Batave, a department store in Paris.* The life of such a prestigious establishment of the period mirrored that depicted in *Au Bonheur des dames* by Émile Zola (1840–1902), teaching him the same discipline and rigor that is found in Matisse's work. Shortly after the birth of Henri, in 1869, Émile married Anna (1844–1920) and they moved to Bohain-en-Vermandois, not far from Cateau-Cambrésis in Picardy. Thanks to a small inheritance that he came into in 1865, Émile decided, with the help of his wife, to take over a grain merchant's store in Bohain. He soon turned it into a prosperous enterprise. Although he inflicted a severe upbringing on Matisse, and later on his younger brother, Auguste, this was counterbalanced with a deep desire to pass on his success, pride, and diligence. Unfortunately, his lack of understanding of Henri's artistic aspirations caused the two men to be in perpetual conflict. Having paid for his son's law studies, he thoroughly disapproved of Henri's departure for Paris, especially as he had been forced to give up the idea of making Henri his successor in the business. However, he paid him a regular allowance, without which Matisse and his little family could not have survived. In 1903, when Matisse returned to Bohain to escape the consequences of the Parayre* scandal, his father's attitude toward him became even more hostile. His pride was wounded because the presence of Matisse caused an atmosphere of animosity, so their relationship tended to revolve around the visits of Matisse's children. Anna always took her son's part during these crises, and continued to believe in him through thick and thin. In the dispute between father

Henri Matisse and his mother, c. 1887.

and son, she played the difficult role of go-between. "My mother loved everything I did," Matisse used to say. A milliner by profession, she passed on to him her sense of color, which she had developed by decorating china, and she also showed him the art of the portrait.* Throughout her life, Anna was concerned for her son's welfare, and she cherished him and his children.

Jean, c. 1901.
Pen and ink,
11.7 x 9.3 in.
(29.7 x 23.7 cm).
Private collection.

Matisse, Jean and Pierre

Jean Matisse (1899–1976) was born in Toulouse when Henri was thirty years old. The painter was not yet able to earn a living from painting, and could not have survived without the allowance paid to him by his father. Jean was nine months old when his mother Amélie,* who was pregnant again, decided to open a store in order to contribute to the household income. The birth of Pierre (1900–1989) at Bohain-en-Vermandois gave Matisse the opportunity of rendering homage to the author Guy de Maupassant and his novel *Pierre et Jean*. The boys were baptized at Bohain on the same day in 1901, and spent their childhood shuttling between northern and southern France. Jean was very fond of his aunt Berthe; Pierre loved his grandmother and his half-sister Marguerite,* who spent more time in Paris.* Although Pierre dreamed of becoming a sailor like his playmates in Collioure, from the age of five he became seriously interested in his father's paintings. He would copy them and even sold a picture to Berthe Weill, one of the dealers* who traded in Matisse's work. The artist began expressing ever-greater interest in the drawings that his children produced, and he loved to use them as models.* Pierre was not merely the central character in *The Piano Lesson*. He was also the projection of his will. Matisse took him out of high school so that he could concentrate on studying the violin. World War I interrupted these plans; Pierre volunteered before he could be drafted. At the age of twenty-two, he enrolled at the Académie Grande-Chaumière, where he met Alberto Giacometti (1901–1966). He then emigrated to the United States, settling in New York, where he opened an art gallery in 1932. The work he exhibited came from the greatest exponents of contemporary art. Jean, who appeared to have been destined to become a cellist, actually became a sculptor.

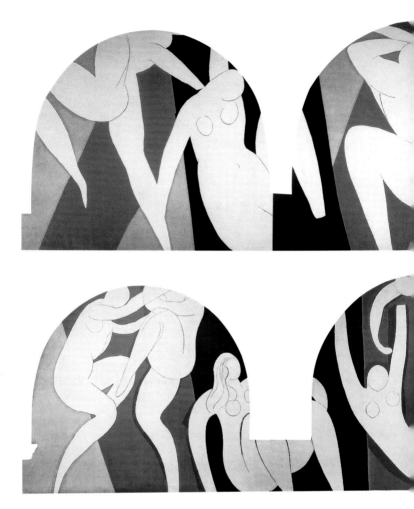

Top: *The Dance* (first version), 1931–1932. Oil on wood panel. Left 11 ft. 2 in. x 12 ft. 8 in. (340 x 387 cm). Center 11 ft. 8 in. x 16 ft. 5 in. (355 x 498 cm). Right 10 ft. 11 in. x 12 ft. 10 in. (333 x 391 cm). Musée national d'art moderne, Paris.

■ **Merion Dance, The**

In late 1930, after making several visits to the location, Matisse began the fresco that Dr. Barnes had commissioned for the foundation that he opened in 1922 at Merion, a suburb of Philadelphia. The collector* left the theme entirely to Matisse's discretion; he merely had to fulfill a single requirement, to respond to the scale of the monumental surface to be painted. It consisted of three arched spaces located over three huge

french doors. Matisse rented a garage in the center of Nice and started work on a 220-square-foot (72-sq.-m) canvas that he divided into three arches almost 12 feet (4 m) across and around 10 feet (3 m) high. Always careful to maintain the balance of the composition, he instituted the system of colored cut-outs or gouaches découpages* that enabled him to move the shapes around as he chose, or to modify them within the area of the canvas. The figures

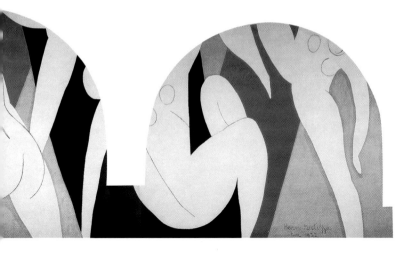

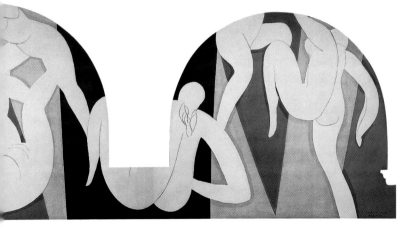

in the 1932 version of *The Dance* were first sketched in shades of blue, and this version can be seen in the Musée d'Art Moderne de la Ville de Paris, where they punctuate the space around them with their striking yet light whiteness. But this first version proved to be too small, and it was not until the following year that Matisse achieved the work that was installed at Merion and that pursued "the idea already expressed in part of the painting that is in the Barnes Foundation Museum in Merion and is entitled *Le Bonheur de vivre* (or *La Joie de vivre**) (*The Joy of Living* or *The Joy of Life*)." By attaching his stick of charcoal to the end of a bamboo rod, and drawing directly onto the canvas, Matisse was able to create limpid figures that were fully in keeping with the Golden Age. As a precursor to his work in the chapel at Vence,* he managed to create "in a limited space, the impression of vastness."

Bottom: *The Dance* (second version), 1932–1933. Oil on wood panel. Left 11 ft. 2 in. x 14 ft. 6 in. (340 x 441 cm). Center 11 ft. 8 in. x 16 ft. 6 in. (356 x 503 cm). Right 11 ft. 1 in. x 14 ft. 5 in. (338 x 439 cm). The Barnes Foundation, Merion, Pennsylvannia.

Henri Matisse and his model, Lydia Delectorskaya, Nice, c. 1943–1944.

■ MODELS
The "Main Theme" of Matisse's Dream

Matisse met Camille* because she had been his model at the École des Beaux-Arts. Yet, Amélie* became his favorite model, before he resorted more and more frequently to using his daughter, Marguerite.* It was the portrait* of Marguerite, in the simplicity of its Primitivism,* that Picasso* chose when he and Matisse swapped paintings. Marguerite and Amélie are generally represented in a way that is both realistic and decorative, introducing a portrait-icon dialectic.

In 1916, Matisse hired Lorette, a beautiful Italian, who was the model for the painting entitled *The Painter and his Model*,* and for numerous other works that enabled him to leave Cubism* behind. When the painter moved to Nice, he chose Antoinette Arnoux, who posed for the most famous of his drawings. She was succeeded in the 1920s by Henriette Darricarrère, a movie actress, who acted in his Oriental theater in the Nice apartment. For Matisse, these young women were not just figures but genuine sources of inspiration. They were the "main theme" of his work because, as he explained, "I am absolutely dependent upon my model, whom I can observe freely, and I then decide how to create the pose that is most natural for her. When I take on a new model, it is when she becomes relaxed that I realize the most suitable pose for her and I become a slave to it. I keep these young girls for a few years, until I am no longer interested in them." He never tired of Lydia Delectorskaya, however. She started work as his assistant, later becoming his model, and stayed with him for the rest of his life.

Moreau, Gustave

Gustave Moreau (1826–1898) was the son of an architect. He studied at the École des Beaux-Arts from 1848 through 1849, and his classical training was enriched by studying the Romanticism developed by Théodore Chassériau (1819–1856). After a long stay in Italy, during which he studied the art of the Renaissance, and as the master of the emerging Symbolist* movement, he produced *Oedipus and the Sphinx* in 1864. His paintings are the products of his mystical fervor, a permanent allegory of Antiquity and the history of Christianity that finds its echo in the whole Symbolist movement of the late nineteenth century, as well as in the poetry of José Maria de Heredia (1842–1905), or even the novels of Marcel Proust (1871–1922). In 1892, Moreau became a teacher at the École des Beaux-Arts, where he taught the future adherents of Fauvism,* who appreciated his tolerance and the paradoxical nature of his teaching. While encouraging his students to copy in order to complete their apprenticeship in drawing, he initiated them into understanding color just as Delacroix (1798–1863) had taught it to him. His own work was closer to that of Rouault,* to whom he handed over his studio, and he guided Matisse for nearly six years, helping to restore his self-confidence. Matisse told how "Gustave Moreau said to me, 'You are not going to simplify painting to that point, reduce it to that. The painting will no longer exist.' And then he came back and said to me, 'Don't listen to me. What you are doing is more important than anything I tell you. I am only a teacher, I understand nothing.'" But for Gustave Moreau, "the painting that will survive is that which has been dreamed, thought about, considered, and comes from the mind [...]." "Painting means imagining color." Matisse would remember this and put it into practice throughout his life.

Gustave Moreau, *Œdipus and the Sphinx*. Watercolor, 13.8 x 7.1 in. (35 x 18 cm). Musée du Louvre, Paris.

■ Moroccans, The

It would appear to be in the spring of 1913, shortly after returning from his second trip to Morocco,* that the idea came to Matisse for *The Moroccans*. The work was not finalized until 1916, in the midst of the turmoil of World War I, after a considerable period of reflection, as witnessed by the letter he wrote in February to his friend Camoin:* "My head has been in a spin for a month over the Moroccan painting I am working on at the moment; it is the terrace of the little café in the Casbah that you know well. I hope to extract myself from it, but it is painful. I have not had any stomach pains yet, but I am expecting them." Even though he had brought back a large number of sketchbooks, Matisse was experimenting with a new "feeling," that of remembrance. Returning to the compound

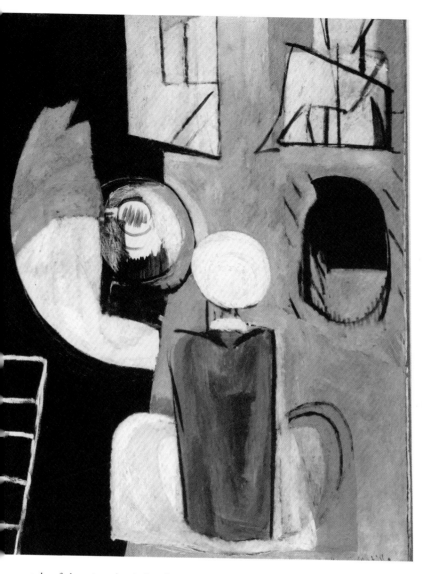

style of the triptych—induced
by the religious nature of
his work and developed during
his stays in Morocco—the can-
vas is divided into three parts.
The Tangier Casbah is in the
upper left-hand corner, a stall
displaying bitter apples and
watermelons below it, and
Moroccans sitting on the famous
café terrace taking up the whole
of the right-hand side. The
composition is united by the
black background and rests on a
geometric representation that
defies depth and is abstracted
from reality. It is a place of con-
flict between a desire for
simplification and a refusal to
give in to the ease of abstrac-
tion. The shapes of Matisse's
landscape dissolve into its
atmospheric "feeling." But the
luminosity of the spherical
masses ensures the musicality of
the painting, at the same time as
the firm outlines make it vibrate
with energy.

The Moroccans,
1916.
Oil on canvas,
5 ft. 11.4 in.
x 9 ft. 2.1 in.
(181.3 x 279.4 cm).
The Museum
of Modern Art,
New York.

■ MOROCCO

I n January, 1912, Matisse and Amélie* visited Morocco, in the footsteps of Delacroix (1798–1863). They first stayed in Tangier, remaining until April, but the trip went badly. The city was hit by a flood, forcing them to remain indoors for days on end, trapped in their room in the Hôtel de France. To relieve the boredom, Matisse worked at his painting but also at his drawing, resorting again to a subject he knew well: the still life.* Furthermore, on this first trip, as on the second that he took with Camoin* from November 1912 through February 1913, he produced numerous sketchbooks that served as studies for some of his paintings. Many of them were real little treasures, evidence of his evocative drawing skills. Then "Fine weather finally arrived, delightful and charming." With the veil finally lifted, Tangier was able to reveal the light of its magnificent architecture and luxuriant vegetation. With its emphasis on interiors, Matisse's Moroccan work offers up the secrets of a fascinating and mysteriously silent city. From the portraits* of Zorah, captured in a sort of contemplative weightlessness, to the open windows, or the *Entrance and Minaret, Mosque in the Casbah,** the canvases of this period are based on a harmony of amazingly clear color. Through the landscapes that he observes in detail, as well as through the Moroccan people he chooses to pose for him, Matisse arranges all the plastic elements that form part of the language of his painting. The portraits* of the period are overtly simple and open in a style reminiscent of Russian icons.

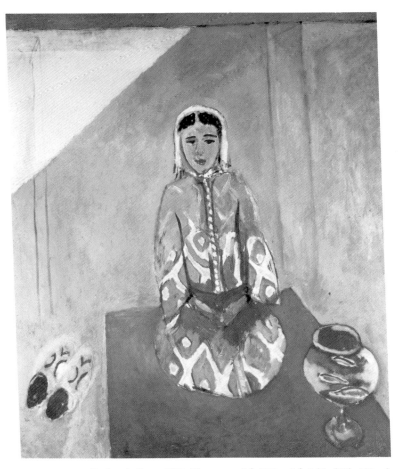

Zorah on the Terrace, 1912. Oil on canvas, 3 ft. 9.7 in. x 3 ft. 3.4 in. (116 x 100 cm). Pushkin Museum, Moscow.

They are solidly constructed, based on the combination of areas of flat color. This total immersion in the Orient,* which enables him to "renew his contact with nature better than the application of a living theory enabled him to do, but with certain limitations like those imposed by Fauvism,*" effectively caused him to simplify form. Matisse sometimes veered toward abstraction as part of the expressive synthesis that was characteristic of his genius, but never totally committed to it.

On his return from Morocco, he continued in the same vein, attempting to depict his feelings, and constantly reaffirming his desire to convey sanctity: this first emerged in *The Dance** and was strongly expressed in *The Conversation*,* painted between the first and second trip. The exhibition of the results of his Moroccan trip was extremely successful, collectors* vying with each other to purchase his works. From now on, Matisse's worries were over. All he had to do was to enter into his dream.

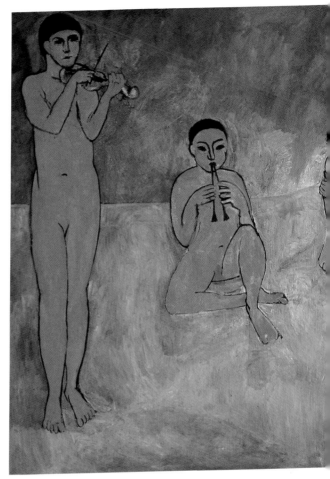

The Music, 1910.
Oil on canvas,
8 ft. 6.4 in.
x 12 ft. 9.3 in.
(260 x 389 cm).
Hermitage
Museum,
St. Petersburg.

■ Music, The

So delighted was Sergei Shchukin by *The Dance** that he commissioned Matisse to paint a second decorative panel on the theme of music. As in *The Dance*, the painter uses five figures and three colors for *The Music*—blue, green, and red— but the scene acquires a different dimension that is both more intense and stranger. The elegance of the dancing figures gives way to the Primitivism* of the musicians who are dotted, like the notes in an orchestra part, in an arbitrary space. They are stylized in shape and in anatomical detail, but have a two-dimensional aspect that makes them appear as abstractions, accentuating the decorative nature of the composition. Inspired by *The Old Musician*, painted by Manet (1832–1883) in 1862, Matisse's *The Music* is being played, however. You can almost hear it. The way that all the figures, whether sitting or standing, face front, explicitly draws attention to them in an interminable dialog that reinforces the absence of a link between them. Pierre Schneider claims, "the frontality that dissociates the figures from each other in *The Music* is also the instrument that sanctifies them." By entering into *The Dance* and imbuing his figures

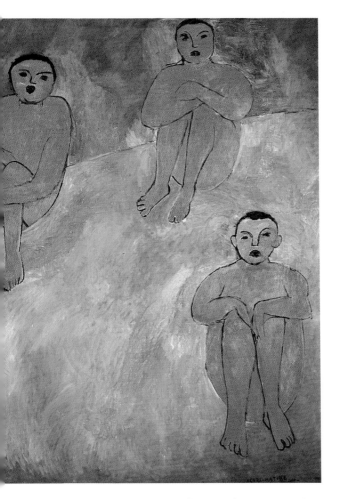

with the "quasi-religious senti-ment" that he feels in life, Matisse restored to painting its original aim, namely to use form to reflect the intensity of the content. In *The Music*, every-thing becomes more abstract and impalpable, as if the passion of the painter came from the unfathomable depths of his being and gave that which is sacred the invisible and absolute nature that really suits it.

◼ Neo-Impressionism, Neo-Impressionist

Although the last Impressionist Exhibition was held in 1886, Georges Seurat's (1859–1891) *Sunday Afternoon on the Island of La Grande Jatte* appeared on the scene in 1887 as a Neo-Impressionist manifesto. Neo-Impressionism was the result of a scientific concept of painting based on orderliness, favoring the depersonalization of the brushstroke and a multiplicity of symbolic components. It retained from Impressionism[*] the capacity to produce a brightly colored version of the world, but departed from its spontaneous coloration by rejecting any formal decon-struction. The Divisionist technique, an offshoot of Neo-Impressionism, based itself on the retinal perception theo-ries of Eugène Chevreul and

The Gate of Signac's Studio, 1904. Oil on canvas, 11.8 x 9.7 in. (30 x 24.5 cm). Private collection.

Charles Henry. The Divisionist or Pointillist technique was based on an irrealism that was devoid of all subjectivity. Illustrated by the work of Edmond Cross (1856–1910); its theoretician was Paul Signac* (1863–1935), who wrote an essay in 1899 entitled *From Delacroix to Neo-Impressionism.*

Matisse met Signac in the winter of 1903–1904, but it was during the summer that he spent at Saint-Tropez that he was directly confronted with Divisionism. *The Terrace at Saint-Tropez,* however, owes more to the work of Marquet,* and although it angered Signac, it remains one of Matisse's best

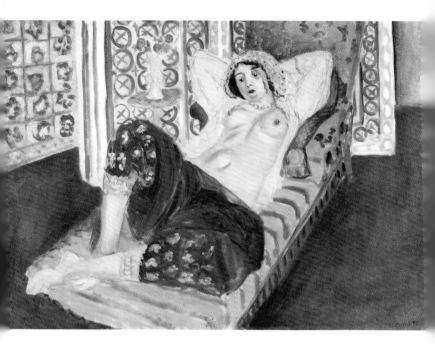

Neo-Impressionist paintings. Reminiscent of Cézanne's* color constructions, it has all the scintillating harmony of Matisse's Collioure landscapes. After returning to Paris,* Matisse entered a new phase with *Luxe, calme et volupté*.*

■ Odalisque in Red Culottes

Once he had settled in Nice, Matisse sought inspiration from sculpture* in order to rediscover the fullness of shape. "I try to put inside me the clear and complex concept of Michelangelo's composition." It was Michelangelo's figure of Aurora, lying at the feet of Lorenzo di Medici, that encouraged Matisse to find new postures for his reclining nudes, and that inspired *Blue Nude, Souvenir of Biskra*.* Distortions of the bust or hips were counterbalanced by the tilted support and the dynamic curve of the abandoned pose in *Odalisque in Red Culottes*, painted in 1921. The model—Henriette Darricarrère—is propped up against cushions to indicate her lasciviousness, and the painter can thus concentrate on what surrounds the body and play on the carnal consistency. From Cézanne,* he borrowed the art of constructing space by juxtaposing simple shapes, to which he gave the thickness of a sculpture by Michelangelo. The *Odalisque in Red Culottes* looks out nonchalantly at the viewer, whose eye is drawn to the warm colors and exotic decor. She is the first of many odalisques who posed for Matisse in the Oriental theater that he created in his Nice studio. Her nudity is confined to the bust, and melts into the patterned fabric of her culottes and her open blouse. The odalisque is as decorative as the setting in which she is placed. In this way Matisse emphasized the fact that the women of his fantasies were the result of representation rather than of illusion, because "a great tension is being hatched, one that is of a specifically pictorial nature."

Odalisque in Red Culottes, 1922. Oil on canvas, 19.7 x 24 in. (50 x 61 cm). Musée de l'Orangerie, Paris.

■ ORIENT, THE

The Orient—or what is known today as the Middle East—attracted much interest in France as a result of Napoleon's Egyptian campaign in 1798; at the beginning of the nineteenth century there was a real craze for all things Oriental. It inspired many works of art, both good and bad, including *Les Orientales*, a novel by Victor Hugo written in 1829. Ingres (1780–1867), Delacroix (1798–1863), and Géricault (1791–1824) were the great painters of the period, all of whom dreamed of the Orient, its landscapes, the heat, the fragrances, the fabrics,* and, above all, the indolence and luscious curves of the women. Although a few made the journey, most artists discovered the Orient in the Louvre art gallery in Paris,* admiring the treasures brought back by Vivant Denon. Then, gradually, the artists changed: their observations became more acute, and their renderings more realistic. Their love of the picturesque and taste for exoticism was supplanted by an ethnological approach, encouraged by France's colonial policy. As the symbol of this new impetus in "official" art, the Société des Peintres Orientalistes Français considered it a duty to promote the love of Oriental people and their costumes. Eventually, the excitement palled, but for some people the Orient continued to be the incarnation of another world that only appeared in dreams, a kingdom of Primitivism* in which everything was purity and harmony. Matisse was well aware of the Oriental paintings by Delacroix, some of them moving, and soon understood the value of the "exotic" art that excited his sense of color and decoration. He was familiar with Islamic art, thanks mainly to the exhibits he saw in the Louvre and at the 1900 Exposition Universelle. He also spent much time at the exhibition held at the Pavillon de Marsan in 1903. In 1910, he and Marquet* even visited Munich to investigate the masterpieces of Islamic art on show there, and he reported how this trip had encouraged him in his research. "The Persian miniatures, for example, showed me all the possibilities of my sensations. Through these artefacts, this art suggests a larger space, a truly plastic space. It helped me to break out of the painting of intimacy." Attracted by the concept of continuous decor signified by the horror of empty space that is peculiar to Islamic

Interior with Egyptian Curtains, 1948. Oil on canvas, 3 ft. 7.8 in. x 2 ft. 11.1 in. (116.2 x 89.2 cm). The Phillips Collection, Washington.

art, Matisse adopted the elements that constitute its two-dimensional pictorial space—expanses of pure color, the arabesque used in drawing, and the absence of modeling. Islamic art also enabled him to resolve his self-doubts on the relationship between form and expression since, as the champions of decorative art, "the Orientals have turned color into a means of expression." From Cézanne* he had learned composition by planes and construction by lines of force. By reconciling these with the magical coloration of Oriental art, Matisse gave his paintings the extraordinary property of being both form and color simultaneously.

■ Painter and His Model, The and The Artist and His Model

In the course of the winter of 1916–1917, Matisse created *The Painter and His Model*, always intent on simplification, but also with the intention of freeing himself from the Cubist* movement.

In another representation of the duality of *The Conversation*,* the picture contrasts the figure of model* in a green dress who sits in a corner of the studio,* and that of the painter, seated in the foreground with his back to the viewer. Amélie* was succeeded as a model by Lorette, an Italian whom Matisse painted diligently. The left-hand side of the canvas contains the easel and the painted canvas and is counterbalanced on the other side by the open window.* Instead of creating a peephole to the outside world, the window is sidelined, thus drawing the eye to the center of the room, where all the action is taking place. Even though the scene outside the window is painted carefully, the mirror on the facing wall is blank. Its presence gives depth to the painting and serves the same purpose as the painting on the wall in *The Artist and His Model*, which

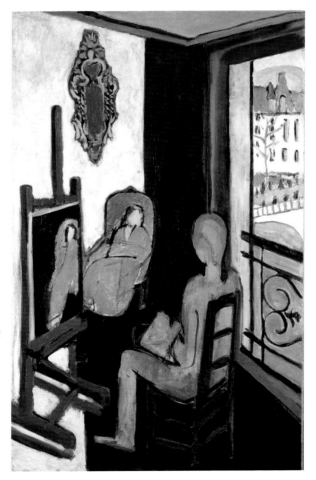

The Painter and his Model, winter 1916–1917. Oil on canvas, 4 ft. 9.7 in. x 3 ft. 2.2 in. (146.5 x 97 cm). Musée national d'art moderne, Paris.

Matisse produced in 1919. In the latter painting, there is an interplay between the objects in the room and the role of the model, who is identified by her nudity. In the first painting, Matisse shows himself as alone in his self-questioning about the portrait,* and the flesh-colored palette is painted as an extension of his hand, as if there were some osmotic relationship between the painting and his working consciousness. He shows himself as confronting two different worlds: that of the image he is painting—Lorette in a green dress against a black background—and that of Lorette as he really sees her. In *The Artist and His Model*, brightly lit and full of detail, Matisse seems to have resolved his self-doubt. Even the nude model is in a more relaxed pose.

■ Parayre, Armand and Catherine

Armand Parayre (1844–1922) was a teacher in a little village near Toulouse, in southern France. He was deeply committed to progress and democracy, and considered education to be an important guarantor of the continuation of the French Republic. That is why Gustave Humbert, the representative of the Haute-Garonne in the French parliament, decided to hire him as a Latin tutor for his son Frédéric, and later as an assistant. Armand, his wife Catherine (1848–1908) and their two daughters, Berthe and Amélie* (who would later marry Matisse) thus followed Humbert to Paris.* This brilliant politician became a senator, and subsequently attorney-general. In 1865, Parayre resigned from his post as tutor to become a

publisher, and published several newspapers that supported Humbert's son's bid to enter the legislature. Four years later, the young representative lost his seat. Armand Parayre, after a short stay in Madagascar, became the administrator of the Humbert family's property. Blinded by their deep loyalty to the Humbert family, the Parayres soon found themselves unwitting accomplices in a pension-fund fraud. When the crime was exposed, they became the scapegoats, and this blackened the family name of Matisse by association, news of the scandal having reached Bohain-en-Vermandois. Armand Parayre was arrested on December 21, 1902, but was able to prove his innocence in the following month. Released from prison, he and his wife took refuge with their daughter Berthe, in Rouen. Matisse greatly admired his mother-in-law, Catherine, for her constancy and loyalty. She had fought for years to protect the wealth of the Humbert family, and had become the trustee of their valuable art collection. She was greatly affected by the betrayal and never fully recovered from the shock.

■ Paris

Matisse enrolled at the Sorbonne University at the age of seventeen in order to study for a law degree. Yet it was not until 1891, when he switched to the École des Beaux-Arts, that he truly tasted the pleasures and the pains of student life. Although still very active in organizing shows—and the official Salon that would ensure a career for those artists allowed to exhibit there—the role of the École des Beaux-arts was being

disputed to an ever-greater extent. The first Salon des Refusés, the exhibition of artists whose work had been rejected by the Salon jury, was held in 1881, followed a few years later, on the initiative of Puvis de Chavannes* (1824–1898), by the Salon de la Société Nationale des Beaux-Arts. While a student, Matisse attended concerts and enjoyed performances at the new Opéra-Comique. Exhibitions held in 1893 at the Palais de l'Industrie and in 1894 at the Palais de l'Élysée enabled him to discover Islamic art and Japanese woodcuts. In fact, it was the Japanese crêpe paper prints bought on the Rue de Seine that showed him how color could be used. In the summer of 1894, he rented an apartment at 19, Quai Saint-Michel, in what was then a working-class neighborhood,

and sent work to be exhibited at the shows. In 1895, he discovered the work of Cézanne* when he visited a retrospective of the artist organized by the dealer,* Ambroise Vollard. In 1897, part of the art collection of the recently deceased Gustave Caillebotte (1848–1894) was exhibited in the Musée du Luxembourg, enabling many artists to discover the Impressionist* work collected by the painter. Gustave Moreau,* the only teacher who was respected by Matisse, died the following year. The winter of 1899 marked a long and depressing period for the artist, who had been unable to make any headway in his career. The 1900 Exposition Universelle was followed by a Van Gogh (1853–1890) retrospective at the Bernheim-Jeune gallery. In 1903, a group of artists, led by Frantz Jourdain (1847–1935), the architect who designed La Samaritaine department store, created the Salon d'Automne, a new outlet for young French aspiring artists, whose work was also encouraged by the many new art dealers.* Cézanne's first major exhibition was held at the 1904 Salon d'Automne. The year 1905 saw the arrival of Fauvism* on the art scene and first official exhibition of Van Gogh's work, organized by Signac* (1863–1935) and Matisse at the Salon des Indépendants. In 1907, Braque's (1882–1963) and Picasso's* Cubism* was first displayed. Guillaume Apollinaire (1880–1918), the poet who began writing as an art critic in 1910, published *Les Peintres cubistes* in 1912. World War I stopped the exhibitions, but in 1918 Matisse and Picasso joined forces in an

The 1900 Exposition Universelle, the Eiffel Tower and the Night Globe.

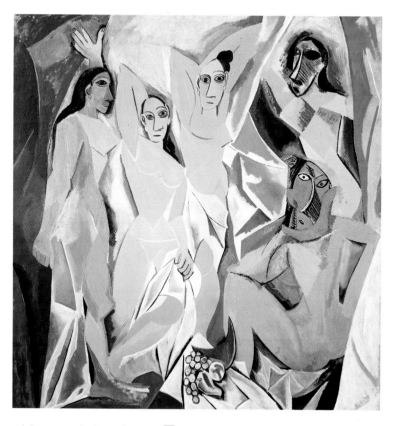

exhibition in which Apollinaire collaborated at the Paul Guillaume gallery. Matisse was now spending more time in Nice than in Paris or Issy-les-Moulineaux, but was able to design the sets and costumes for *Song of the Nightingale*, the ballet created by Diaghilev (1872–1929) with music by Stravinsky (1882–1971).

In 1924, André Breton (1896–1966) published *Le Manifeste du surréalisme* [*The Surrealist Manifesto*].

Thereafter, Matisse exhibited throughout the world. After World War II, when many French artists moved to the United States, Matisse moved back to Paris, where he exhibited regularly.

■ Picasso, Pablo

In 1900, Pablo Ruiz Blasco, known as Pablo Picasso (1881–1973), who had been born in Malaga, Andalusia, Spain, began making frequent trips to Paris.* In April, 1904, he shared an apartment with Fernande Olivier in Montmartre. Picasso first met Matisse at the 1906 Salon des Indépendants, at which the latter exhibited *La Joie de vivre*.* According to Picasso, the two men soon realized that the future of modern art was in their hands. During a dinner held in the fall by Gertrude Stein and her brother, who had introduced the painters, Matisse enabled Picasso to discover African art. In his 1908

Pablo Picasso, *Les Demoiselles d'Avignon*, 1907. Oil on canvas, 8 ft. x 7 ft. 7.8 in. (244 x 233 cm). The Museum of Modern Art, New York.

book *Écrits et propos sur l'art [Notes from a Painter]*, Matisse remembers: "I often used to visit Gertrude Stein at her home on the Rue de Fleurus, and when doing so I would pass a small antique shop. One day I noticed a little Negro's head in the window, a wooden sculpture that reminded me of the massive red porphyry heads in the Egyptian collections in the Louvre.... So I bought the head for a few francs and brought it with me to Gertrude Stein's. I found Picasso there, who was very impressed by it. We talked about it for a long time, and it was the start of our mutual interest in African art...." African art had an immediate effect on Picasso's work, because it resolved the difficulties he had encountered when painting the *Portrait of Gertrude Stein*. In the case of Matisse, its effect was slower and more subtle. By frenetically borrowing the paths to distortion that eventually led him to dissolve shape into abstraction, Picasso initiated Cubism.*

His *Demoiselles d'Avignon*, which was a response to Matisse's *La Joie de vivre*,* nevertheless owes more to *Blue Nude, Souvenir of Biskra** than to the art of Africa. The two men were again brought together on the outbreak of the First World War in 1914, removed as they were from the hostilities. During this period, Picasso was seized with uncertainty as to the future of his painting, and produced a work called *The Painter and His Model*. Matisse would employ the same subject only two years later. The complex relationship between these two great painters oscillated

between friendship and rivalry, but they shared the same commitment to their art. This is clear from a letter written by Matisse to his son Pierre* in 1940: "If everyone did their work the way Picasso and I do ours, [the War] would never have happened." The two men would later decide to exchange paintings. Although both found solace in prayer when things were going badly, Picasso disapproved of the chapel project in Vence. "Why don't you decorate a market? You could paint fruits and vegetables," he inquired. But, for Matisse, this was not

something on which he could work "like laborers" because, he claimed, "everything has come from elsewhere, from higher than me." Critical but no doubt admiring, Picasso later said of him, "No one could produce a Matisse. No one other than Matisse could do so."

■ Pink Nude

Matisse was exhausted after working for three whole years on *The Merion Dance.** As a consequence, he returned to his painting at the easel. From April through October, 1935, he concentrated his efforts on *Large Reclining Nude* or *Pink*

Nude, a work that is striking in its monumentality and distortion. His Russian assistant, Lydia Delectorskaya acted as model* for the painting; after each session of posing she would erase those areas of the painting that Matisse wanted to rework. Photographs taken during the successive stages of creation were sent to the collectors* in Baltimore who had commissioned the painting. The photographs allowed them to follow the way in which the thought processes of the artist evolved: the "motion picture of his sensitivity." The photos reveal his gradual

Pink Nude,
May–October
1931.
Oil on canvas,
26 in. x 3 ft. 5 in.
(66 x 92.7 cm).
The Baltimore
Museum of Art.

progress from naturalism to Cubism,* stamped with a sensuality that was unique to Matisse. *Blue Nude, Souvenir of Biskra** is an example of Matisse's female fantasies and it is extended into these figures of odalisques and into the bronze sculpture,* created in 1925, entitled *The Night*. The inspiration came from Michelangelo (1475–1564) and shows *The Night* as a nude, leaning forward with bent legs and her arms raised behind her head. The arm position, which is found in *Odalisque in Red Culottes** and elsewhere, is partly preserved here, but the sculptural aspect disappears through the need for linear abstraction.

More than ever, this pictorial simplification turns the background into a stage set and the figure into a symbol. In relegating the last indicators of three-dimensional space to the

Camille Pissarro,
The Watering Hole, Eragny.
Oil on canvas,
13.8 x 25.6 in.
(35 x 65 cm).
Musée du Louvre, Paris.

background, Matisse finally gave in to the Oriental esthetic. Cézanne's* bathers were no longer relevant and could be sent to join the collection in Paris's Petit Palais.

■ Pissarro, Camille

As a young admirer of the work of Corot (1796–1875), Camille Pissarro (1830–1903), whose art is typified by a unity of color and texture, made friends with Monet (1840–1926) at the Académie Suisse in 1859. He took refuge in London during the Franco-Prussian War of 1870, when his home in Louveciennes was completely destroyed, along with most of his work. Upon returning to France, he rejoined his friends in the Impressionist* movement, becoming a sort of father-figure to them.

Pissarro then decided to move toward more structural but less instinctive painting. In 1885–1890, he became an adherent of Neo-Impressionism,* though he continued to be interested in new drawing and engraving techniques, and became a master of the colored etching. He was very supportive of the new generation of painters, and caused Gauguin* to take the decisive step toward painting in the open air. For Cézanne,* with whom he enjoyed a particularly close and fruitful relationship, he remained "the humble, the colossal Pissarro."

In 1897, Pissarro made the acquaintance of Matisse, who often visited him in his studio. The elderly man advised him to continue with Impressionism. Together they visited the Caillebotte bequest: it was being exhibited for the first time in the Musée du Luxembourg and contained forty or so works by the Impressionists. It was at this period that Matisse painted his first *Dining Room,** which clearly reveals the attention being shown to him by Pissarro. Pissarro also advised him to visit London to see the work of William Turner (1775–1851), and gradually revealed to him the secrets of the art of Cézanne.

■ PORTRAITS

I t was while thinking of his mother that Matisse had "the revelation of life in the study of the portrait." While waiting in line at the post office, he alleviated the boredom by doodling, and "was surprised to recognize the face of my mother in all its delicacy," he explained delightedly. He thus discovered that, contrary to all the teaching he had received, the art of the portrait is inspired by "meditation around the model,*" and resides in the spontaneity of the gesture. "The almost unconscious transference of the significance of the model is the initial act of every work of art and especially of a portrait." The portrait is "one of the most special of the arts" that requires "that the artist be particularly gifted and has the ability to almost completely identify with his model." Although Camille* was the subject of the first series of female portraits starting in 1895, Amélie* became his ideal model from 1898, because their close relationship made such identification possible. Thus, the painting becomes the setting for a dialectic between realism and decoration. The image hides behind the portrait, but the portrait does not lurk far behind the image. The symptoms of a reconciliation between painting and color in 1905 can be seen in the portrait of Madame Matisse known as *The Green Stripe*,* which substitutes an abstraction of the image for the realism of the representation.

Stimulated by the atmosphere in Morocco,* Matisse painted a dozen or so people in Tangier whose expressions rely on a subtle interplay between relationships and the density of expanses of color. These canvases radiate monumentality in the hieratic poses of the subjects, and have a delicate fluidity and simplicity that is a break with previous violence. The portraits of Zorah, that "irritated and annoyed" the painter during the sittings, are examples of the magic that works by transforming the model into a fragile but enigmatic statue. The effects of transparency disappeared from Matisse's work on the eve of World War I. From 1914 onward, his palette darkens. Matisse produced more portraits of his family, as if to compensate for the absence of those from whom he was separated by war. Through contact with the Cubism* of Juan Gris (1887–1927), he schematized

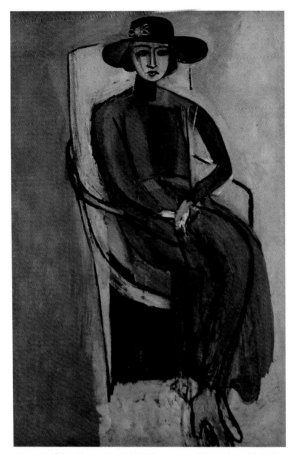

Portrait of Greta Prozor, late 1916, Oil on canvas, 4 ft. 9.5 in. x 3 ft. 1.8 in.
(146 x 96 cm). Musée national d'art moderne, Paris.

his forms, accentuating their geometric nature. In contrast to the way he conveyed the flesh, geometry was used by Matisse as the incarnation of the tragedy of war. Until 1917, his portraits—especially those of Greta Prozor or Sarah Stein—are on the edge of abstraction, while those of his Italian model, Lorette, slide slowly toward realism. Matisse gradually returned to natural representation in *The Conversation,** a style that the war had interrupted. The nudes and odalisques then become the embodiment of his fantasies about women. *The Idol* is an elegant, tender portrait produced while he was recovering from the serious operation he underwent in Lyon, in 1941. Monique Bourgeois was the subject of many of his portraits and had actually come to look after him from September 1942. Until the construction of the chapel at Vence,* Matisse continued his amorous advances toward her, flirting with the woman who was soon to become Sister Jacques-Marie.

■ Primitivism

Nineteenth-century Primitivism is based on two fundamental ideas: a return to original sources, and the foundation of a better world. In the early twentieth century, many avant-garde artists sought inspiration in the primitive art of Asia and Africa in order to rediscover the spontaneity of original shapes and forms. African art, introduced by sailors and colonials, began to be seen in Paris.* Émile Heymann, known as "Father savage," opened a sort of art gallery that was visited frequently by Matisse and other Fauves.* It was in the fall of 1906 that he bought from Heymann the little statuette Vili, which fascinated Picasso* because it so resembled his mistress. Matisse's taste for abstract beauty, which caused

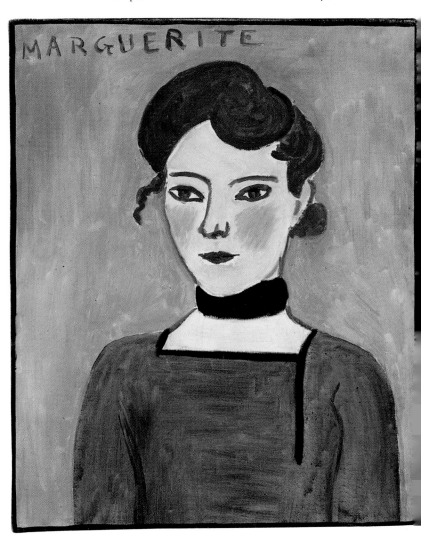

Nimba Mask, Baga (Guinea). Wood and raffia, 4 ft. 1.6 in. x 23.2 in. x. 25.2 in. (126 x 59 x 64 cm). Picasso's personal collection. Musée Picasso, Paris.

Portrait of Marguerite, 1907. Oil on canvas, 25.6 x 21.3 in. (65 x 54 cm). Musée Picasso, Paris.

him to introduce distortion into works such as the *Blue Nude, Souvenir of Biskra*,* were the germ of the idea for his cut-outs—the gouaches découpages*—though he was also inspired in this by Giotto (1266–1337), whom he discovered in the following year. He would later say to Pierre Bonnard:* "When I look at the Giotto frescoes in Padua, I am disturbed at not knowing exactly which scene from the life of Christ I am looking at, but I subsequently understand the feeling that emanates from them because it is in the lines,

the composition, and the color, and the title merely confirms my impression." Giotto's Primitivism was far removed from the innovations introduced by the painters of the Renaissance, who imitated nature by introducing perspective to create a realistic space in a painting, but the medieval painter represented "the culmination of his desires," restoring the arbitrary space in painting that Matisse would attempt to recreate.

■ Puvis de Chavannes, Pierre

See Symbolism.

Reader on a Black Background, August 1939. Oil on canvas, 3 ft x 28. 9 in. (92 x 73.5 cm). Musée national d'art moderne, Paris.

■ Reader on a Black Background

In August, 1939 Matisse produced *Reader on a Black Background,* so the circumstances were the same as when he created the *French Window at Collioure* in 1914, representing a window* opening onto a black void. Here again, black is used instead of light. Although used as a background, the black is adorned in this case by items that are evocative of the artist's work or his inspiration.

Forty years after the first painting of a young girl reading, Lydia has replaced Camille,* continuing the theme. She would be with the artist until the end of his life. She sits beside the table, leaning one elbow on it, occupying the lower left-hand corner of the painting; but she appears to be looking at the central bouquet of flowers that can only be seen as a mirror image. The yellow frame of the mirror and the pink table rebalance the composition, acting as a counterpoint to the

other diagonal. The black contrasts with the primary colors but serves to unify the whole. Color is given free rein, sometimes exceeding the limits imposed in order to better take account of what might happen. For instance, you can see that the leg of the reader seems to be swinging to and fro. She has actually stopped reading and is resting the book on the table while looking at the painter—unless it is you, the viewer, she is gazing at. By interrupting her reading, Matisse accentuates the distance between the spectator and the canvas, as if to mark the extent of his "spiritual space, that is to say a measured space that is not limited by the existence of the objects represented."

■ Romanian Blouse, The

The Romanian Blouse, painted in 1940, constitutes a submission to pictorial space, and occupies a special place in Matisse's work. As in the creation of the *Pink Nude,** the artist made frequent photographs of the development of his work to show how it progressed because, in his own

The Romanian Blouse, 1940. Oil on canvas, 3 ft. x 28.8 in. (92 x 73 cm). Musée national d'art moderne, Paris.

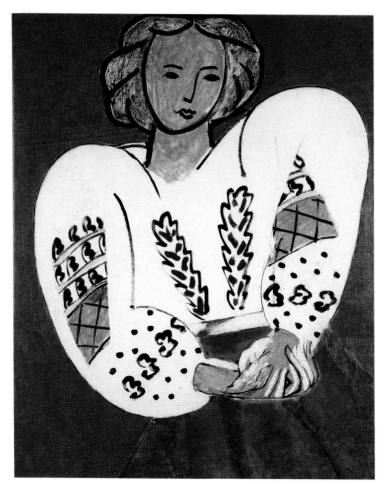

words, "at each stage, I have an equilibrium, a conclusion." He thus transposes to painting the serial nature of sculpture,* making it possible for him to appreciate the various visions of the object, mutated through time. This bust of a woman wearing an embroidered blouse is set against a red background within a frame, like the figures in classical paintings—though it has nothing in common with a classical portrait. Even though it retains a degree of sensuality, the exaggeration of the contours reduces the shapes to their bare essentials. At the same time, the face is given unequaled expressive power, resulting from the skill of the painter who, in order to touch on perfection, elongates the eyes. The embroidery patterns, which are also stylized, appear in the negative, staining the brilliant white of the blouse. This simplification of the decorative aspect, reinforced by the presence of a plain background, is there to stimulate the imagination or leave the viewer free to indulge in a reverie. By entitling the work *The Romanian Blouse*, Matisse twice shifts the subject of the picture and brings it back to the materiality of its decorative substance. Painted on a stretched canvas, the fabric* of the bodice merges with the weave of the canvas and accentuates the symbiosis that is occurring. From this moment on, representation was combined with painting.

▣ Rouault, Georges

Georges Rouault (1871–1958) began studying art at the age of fourteen, attending evening classes at the École des Arts Décoratifs and studying with painters of stained glass. In 1890, he passed the entrance examination for the École des Beaux-Arts, and two years later he became a student under Gustave Moreau.* Like Moreau, he failed to win the Rome Prize, and left the school in 1895, but he began to exhibit his paintings on a regular basis. As Moreau's favorite student and the first curator of the museum that Moreau opened in 1903, Rouault suffered a breakdown when Moreau died but tried to overcome his distress by adopting Cézanne's* revolutionary principles. He was a painter of unrest and defender of the oppressed who discovered the existence of God in 1901 through the writings of Léon Bloy (1846–1917). Rouault adopted a realistic style, his work focusing on the concept of sin. He loved dramatic subjects that he translated with the use of *chiaroscuro*, retaining a palette of dark tones and a fiery, spirited line. His subject-matter came to consist largely of clowns with Christ-like attributes, poetic incarnations of the derisory destiny of man, giving his work a particularly original character. As his iconic development progressed, his art become more and more simplified, eventually abandoning itself totally to mystic passion. If the fiery nature of his painting is close to that of Expressionism, the characteristics that link it to Fauvism* are not very convincing. What he shared with Matisse, and very soon with Manguin* and Marquet,* were the ideas he had been taught of enhancing the expression of form and color, while closely observing the techniques of the "great" paintings. He also wanted to escape from academic teaching and produce art in

a more modern vein. But this was a long way from the open-air painting of the Fauves* or the colored light of the paintings of Matisse.

Russell, John

After the success of *The Reader* in the person of Camille* exhibited at the 1895 Salon, Matisse left for Brittany. He returned to Belle-Île, which he had discovered the previous summer, and made the acquaintance of the Australian painter, John Russell (1858–1930), who lived on the island. Russell had met Vincent Van Gogh (1853–1890), first in Paris,* then in Arles, and had decided to isolate himself from the fashionable world so as to find inspiration more easily. He had a hearty, sporting temperament, and plunged into the activities offered by the Breton coast, involving his friends, women, and children in his pastimes. Matisse loved Russell's good humor and admired his peaceful lifestyle; he also appreciated his genre paintings and

his spirited landscapes. It was through Russell that Matisse discovered Monet's (1840–1926) theories about light, as well as "the feeling" for pure color, as it had been practiced by Vincent Van Gogh.

Guided by these two masters, Russell had been interested for more than ten years in the subject with which Matisse would soon become preoccupied: color. Careful to remove himself from academic training, the young Matisse adopted the cobalt blue and red madder favored by Russell to illuminate white. He also gradually learned to free himself from the precepts of the Flemish school, imbuing his paintings with the first signs of the radiance that characterizes his work. *The Dining Room,* painted on his return from Brittany, owes much to the teaching of Russell and of Pissarro,* but it was in Corsica that this approach became most effective, and where Matisse made the decision to become a colorist.

Georges Rouault and his daughter.

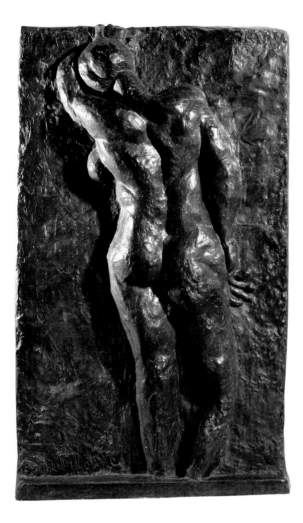

Back I,
1908–1909.
Bronze, lost wax
technique,
6 ft. 2.9 in. x 3 ft.
10.9 in. x 8.3 in.
(190 x 119 x 21 cm).
Musée national
d'art moderne,
Paris.

■ SCULPTURE
"Putting My Mind in Order"

Sculpture occupies a sporadic place in Matisse's work, but his sculpture offers quite a good way of following the development of his artistic thought because it was through sculpture that he would find solutions to his self-questioning about his painting. "I have sculpted because what interested me in painting was to put my mind in order," he explained to Pierre Courthion. Georges Lorgeoux gave him his first lessons in sculpting in 1892 in Gustave Moreau's* studio. The first sculptures produced by Matisse were a pair of medallions decorated by the sweet face of Camille.* In 1900, he concentrated on a sense of movement. Fascinated by Barye's (1796–1875) *Jaguar,* which he had copied, he launched himself into creating the sculpture of a man that he entitled *The Serf,* then he went in search of the ideal teacher. He visited Rodin's (1840–1917) studio, but preferred the latter's assistant, Antoine Bourdelle (1861–1929), whose work was closer to his

Back IV,
1930–1931.
Bas-relief in bronze,
dark patina,
6 ft. 2.9 in. x 3 ft.
8.9 in. x 6.3 in.
(190 x 114 x 16 cm).
Musée national
d'art moderne,
Paris.

aspirations in its simplicity. This fruitful meeting caused him to change his *Serf* into a surprisingly evocative self-portrait and revealed his need to introduce a certain Primitivism* into his work as a sign of freedom. In 1905, he discovered the work of another of Bourdelle's students, Aristide Maillol (1861–1944) of whom he said: "Maillol's sculpture ripens like a beautiful fruit that the hand would like to feel." Yet Matisse, who was already heavily inspired by linearity, had a style that was very different from the massive esthetic that Maillol had borrowed from Greek art. In 1908, studying Cézanne's *The Three Bathers,* he started the series of *Backs.* This study, that parallels the progression of his pictorial expression, was not completed until 1931. It consists of four bronzes that have a magical sensuality, revealed by the glow of day. The importance of the first of Matisse's *Reclining Nude* sculptures, produced in 1906 in Collioure, is that it inspired the famous series of *Blue Nude,** *Odalisques,** and *Pink Nude,** renewed after 1918 when he had come into contact with the sculptures of Michelangelo.

.

◼ Signac, Paul

See Neo-Impressionism.

◼ Still Life

Matisse's first canvas, which he entitled *My First Painting*, was a "still life with books," and was evidence of his faithfulness to the Flemish tradition. Mastering still-life painting is at the heart of academic teaching, but Matisse soon moved on from literal copying to free copying, showing a particular fondness for the art of Chardin (1699–1779). His experience with light encouraged him to lighten his palette and caused him to enrich his vocabulary of golden fruits. Thus began the still lifes with oranges. In 1908, in his *Notes from a Painter*, Matisse expressed his "sentiment" for still life: "In still life, copying the objects is nothing; they need to be given the emotions that they awaken within one. The feeling of the whole scene, the way the objects relate to each other—modified by

their relationship with the others—all this is intertwined like a rope or a snake." At the same time, still life constituted the main field of his painterly experience. Even as late as 1909, *Still Life with "The Dance"* reintroduces a two-dimensional version of *The Dance** into the three-dimensional view of his studio.* The brilliant display of the bunches of flowers seem to echo the frenzied twirling of the naked dancers. Matisse's trips to Morocco* caused him to reproduce fruits and flowers; these became the pretexts for magnificent compositions. Then, in 1915, he produced a Cubist* version of *The Dining Table* by Jan Davidsz de Heem (1606–1684), who had inspired his first *Dining Table.** Yet it was *Still Life with Magnolias*, painted in 1941 on a scarlet background, that remained his "favorite picture" through the combinations of its composition.

Still Life with a Magnolia, 1941. Oil on canvas, 29.2 in. x 3 ft. 3.8 in. (74 x 101 cm). Musée national d'art moderne, Paris.

◼ Studio, The

The theme of the artist's studio was first used by Matisse in 1893 in *Gustave Moreau's Studio*, when it took on a new meaning. From 1900 onward, he used it many more times, combining it with the interiors favored by himself and intimist painters such as Pierre Bonnard.* His life and his painting seemed to be inextricably entwined. Although overtaken by the atmosphere of the Collioure countryside in 1905, the studio subsequently became the pretext for the symbolism of the goldfish,* in the still-life* tradition. When painting and the studio became the actual subject of his pictures, because he became aware of its limitations, of "the rigidity of the frame," then color invaded his paintings. *The Red Studio*, painted in 1912, where only the outlines of the furniture remain, celebrates color as well as the material nature of painting. The works of Matisse that line the walls are incarnations of himself, at the same time as they dissolve into the uniqueness of his intensity. As in *The Painter and his Model*,* Matisse was actually painting a picture within a picture. This duality, which he extends here by inserting the figure twice, as if to stress its pictorial substance in the same way, enables him to distract the eye from the subject and encourage the viewer to reflect. The studio thus becomes a place not only of action but also of contemplation, and not merely a backdrop. During the 1920s, Matisse converted the Nice studio into an Oriental theater, the location for his permanent dialectic between drawing and color, which culminated in *Large Red Interior* painted in 1948.

The Red Studio, 1911. Oil on canvas, 6 ft. x 7 ft. 2.3 in. (181 x 219.1 cm). The Museum of Modern Art, New York.

■ Symbolism

Immersed in a literary phenomenon based on the idea of counter-nature, brilliantly illustrated by the art of Oscar Wilde (1854–1900), Symbolism was a late nineteenth-century spiritualist movement animated by a sort of demonic fervor. Its first manifesto appeared in the French newspaper, *Le Figaro*, in 1886, written by the poet Jean Moréas (1856–1910). It migrated in 1890 into the writings of the painter Maurice Denis (1870–1943), the initiator of the Nabi School, and found its theoretician in the writer and art critic Albert Aurier (1865–1892) who wrote in *Mercure de France*. The expression of a new pictorial sensitivity, and driven by the work of Gauguin,* a work of art should be, according to Aurier: "Firstly, idealist, because its sole ideal would be expression of an idea; secondly, symbolic, because it would express this idea in shapes; thirdly, synthetic, because it would create these shapes and signs in a way that would be generally understood; fourthly, subjective, because an object should never be considered as an object but as the sign of an idea perceived by the subject; fifthly (as a consequence), decorative, because truly decorative painting, as conceived by the Egyptians, and very probably the Greeks and the Primitives, is nothing else than a manifestation of art that is at the same time subjective, synthetic, symbolic, and idealist." It is these plastic shapes that would henceforth embody the symbols that illustrate thought. For Maurice Denis, pictorial symbolism is born of a rejection of naturalistic perception and the idea of the "window open on the world," which had devolved into painting for centuries. In other words, rejecting Courbet's (1819–1877) realism and the positivism developed by the Impressionists, Symbolism refused any idea of modernism and took refuge in disillusionment.

Symbolism was a short-lived movement, lasting only for around ten years, but it is embodied in the art of Gustave Moreau,* Pierre Puvis de Chavannes (1824–1898), and Odilon Redon (1840–1916), and is the basis for many avant-garde movements begun by young artists who rejected the current academic art in order to allow imagination to prevail.

■ Windows

In *The Open Door, Brittany*, painted at Kervilahouen during the summer of 1896, the theme of the door first appears. Matisse used it as a pretext for contemplating a space that leads into a study of light. The painting is the forerunner of the Matisse windows, and does not fall into any traditional pictorial style, but is typical of his work. Pierre Schneider comments, "*The Open Door* symbolizes his artistic ambition, years before he fulfilled it—to take on duality and restore unity." Although he produced numerous views of the Quai Saint-Michel in 1900 through 1905, he did not do so sitting at an easel beside the Seine, as did the Impressionists,* but from the window of his studio.* Matisse did not seek to force the viewer to look at the landscape, but structured his subject on the basis of the lines and limitations of his window. By restricting his reading

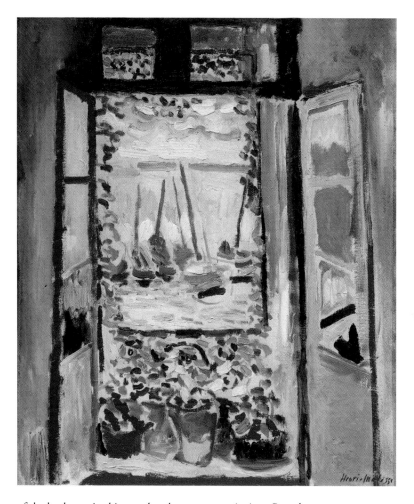

of the landscape in this way, he restores to the representation its value as a material painting. While in Collioure in 1905, he rediscovered landscape and color through the light of the Mediterranean. He then reconstructed the landscape, let it enter his room, and framed it in the window opening. Matisse's windows thus remove the illusory character of the windows inherited from Renaissance paintings, which were a device to introduce perspective. "What one sees through the window," explains Pierre Schneider, "is a flat painting." Thus, in *The Open Window*, the port of Collioure ceases to be a port and

becomes a painting. But the window also represents the moment at which the painter transcended Neo-Impressionism* to take the route to Fauvism.* In 1914, *French Window at Collioure* opens onto blackness, just as the war opened into tragedy. Minimalism stole a march on Cubism* in this instance. Flanked by a blue stripe on one side and a green strip on the other, the distant evocation of nature, the central, imposing, gaping expanse of black suggests an unknown world, governed by extinction. The black is both impenetrable and infinite, seeming to embody the struggle

The Open Window, summer 1905. Oil on canvas, 21.7 x 18.1 in. (55.2 x 46 cm). National Gallery of Art, Washington.

between creative imagination and the difficulty of painting, but above all it imposes itself as a color. The dullness of the black cuts through the light, of which it is simultaneously the incarnation. *French Window at Collioure* questions painting, but also becomes the means of extolling it. *Violin Player at the Window*, painted in 1917–1918, illustrates this theme of the window with just as much expressive power. Just as he is giving a painting lesson* in *The Piano Lesson*, Matisse shows himself playing the violin in the same way a painter uses his brush on a painting. As a metaphor for painting, the presence of the violin serves to identify the painter and links him to the window that serves as a painting. Once again, it is the painting that distributes the lines, colors, and light and is responsible for balance and unity, and the painting that brings them to the surface of the canvas. So just as the image

of the painting only extends over the area of the canvas, Matisse's space only stretches as far as his imagination.

■ **Woman in a Hat, The**
After returning from Collioure in 1905, Matisse decided to transpose his treatment of color to the noble art of the portrait,* and used Madame Matisse to create a work that consisted of a violent explosion of color. This was entitled *The Woman in a Hat*. The work is a gesture of freedom in style and execution, accentuating the contrasting style of the color harmony, and thus conveys the powerful impression of enormous vigor. As the focus of these color and tactile contrasts, Madame Matisse's hat is a permanent interrogation on the space, and a ceaseless reference to the brush-strokes and blue coloring used by Van Gogh (1853–1890). The hat constitutes a baroque motif and an esthetic accessory, a satirical reference to the austerely

Window with Egyptian Curtains, 1947. Pencil, Wally Findlay Galleries, New York.

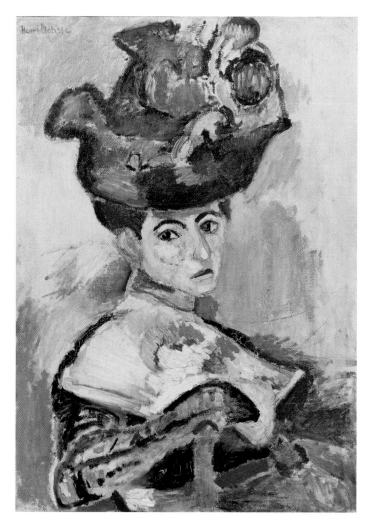

academic portraits on show at the official Paris* exhibitions. The critics hated it, feeling themselves under attack from the violence of its saturated colors and the almost careless execution that daringly broke with the tradition of realism. *The Woman in a Hat* was also very different from the prevailing style of Impressionism.* It was an indication of the limitations of the art of Renoir (1841–1919) and his friends, and was an attempt by Matisse to abase the portrait and tear it down from its bourgeois status, making painting itself the true subject of the work. This painting was at the heart of the scandal that erupted over the paintings which were exhibited at the Salon d'Automne, and showed Matisse's true talent. The collector* Leo Stein, who at first considered the portrait to be "the ugliest daub I have ever seen," finally bought it on the last day of the show. Rescued from destitution, Matisse suddenly became too expensive for young dealers,* such as Daniel-Henry Kahnweiler, who could not afford him and had to make do with a Picasso.*

Woman in a Hat,
1905.
Oil on canvas,
31.7 x 23.5 in.
(80.6 x 59.7 cm).
San Francisco
Museum of Art.

1869 December 31, Henri Matisse born at Cateau-Cambrésis.

1882–1887 Student at the secondary school in St. Quentin.

1888–1889 Law student in Paris, then clerk to a notary in St. Quentin.

1890 Matisse has a "revelation" about painting, and takes classes at the Quentin-de-la-Tour School in St. Quentin.

1891–1892 Moves to the Quai Saint-Michel in Paris and enrolls at the Académie Julian. He soon leaves, however, for Gustave Moreau's studio, where he meets Camille.

1895–1897 Finally passes the entrance examination for the École des Beaux-Arts. Spends the summer in Brittany, where he joins forces with John Russell who introduces him to Impressionism. First official recognition, when the French government buys *The Reader*.

1898 Matisse leaves Camille, but acknowledges their daughter, Marguerite. He meets and marries Amélie Parayre. They honeymoon in London and he later discovers the Mediterranean light in Corsica.

1899 Birth of Jean. Matisse buys *The Three Bathers* from Cézanne.

1900 Birth of Pierre. Matisse spends time at the Académie Carrière.

1901–1902 After exhibiting at the Salon des Indépendants and at Berthe Weill's, returns to Bohain to live with his family.

1903 Matisse exhibits at the first Salon d'Automne.

1904 Ambroise Vollard organizes Matisse's first one-man show. Matisse spends the summer in Saint-Tropez with Paul Signac, who encourages him to move on to Neo-Impressionism.

1905 *Luxe, calme et volupté* is a success when exhibited at the Salon des Indépendants. The scandal of *The Woman in a Hat*, exhibited at the Salon d'Automne, turns Matisse into a celebrity. Fauvism is born.

1906 Leo Stein buys *La Joie de vivre*, painted in a former convent of the Invalides and exhibited at the Salon des Indépendants. Matisse meets Picasso, travels to Algeria, and stays in Collioure for the first time.

1907 *The Blue Nude, Souvenir of Biskra* is exhibited at the Salon des Indépendants. Matisse creates his academy and spends time in Italy.

1908 The Russian collector, Sergei Shchukin, buys *Harmony in Red—The Red Dining Table*.

1909 Matisse moves to Issy-les-Moulineaux in the suburbs of Paris.

1910 First retrospective at the Bernheim-Jeune gallery. *The Dance* and *The Music* are exhibited at the Salon d'Automne. Visits Germany.

1911 Trip to Spain. Matisse paints *The Conversation*, and visits Moscow to supervise the hanging of *The Dance*.

1912–1913 Trips to Morocco, where he paints *The Arab Café* and *Entrance and Minaret, Mosque in the Casbah*. On his return to Issy, Matisse produces *The Goldfish* (1912) and *Portrait of Madame Matisse* (1913).

1914–1918 Matisse takes refuge with his family at Collioure, visiting Nice several times. Meets Auguste Renoir, Pierre Bonnard, and Juan Gris. He paints *The Painter and His Model*,

CHRONOLOGY

The Moroccans (1916), and *Bathers by a River* (1917). Holds a joint exhibition with Picasso (1918).

1920–1921 Now spends part of the year in Nice, renting an apartment on the Place Charles-Félix. Produces the sets and costumes for *Song of the Nightingale.*

1924 Exhibitions in New York and Copenhagen.

1925 Matisse returns to Italy with Marguerite and Georges Duthuit.

1927 His son Pierre arranges an exhibition in New York for him. Matisse receives the Carnegie Prize from the Carnegie Institute in Pittsburgh.

1930 Travels across the United States on his way to Tahiti.

1931–1933 Paints *The Merion Dance.* Retrospectives in New York, Basle, and Paris. Lydia Delectorskaya becomes his assistant. Publication of Stéphane Mallarmé's *Poésies.* While resting in Italy, Matisse visits Padua several times to study Giotto's frescoes.

1935 Paintings produced this year include *The Dream* and *Pink Nude.* Publication of James Joyce's *Ulysses,* illustrated by Matisse.

1938 The artist moves to the former Hotel Regina at Cimiez.

1939 Spends the summer in Paris, returning to Nice on the outbreak of war.

1940 Matisse produces *The Romanian Blouse.*

1941–1942 Undergoes a very serious operation in Lyon that causes him to become bedridden. Produces a magnificent collection of drawings entitled *Themes and Variations.*

1943 Matisse develops the painted cut-out or découpage technique. He leaves Nice, which is under threat of bombing, and buys a home in Vence that he calls "Le Rêve" ["The Dream"].

1945 Exhibits with Picasso in London.

1946 Produces the first large gouaches découpages, reminiscent of Oceania and Polynesia.

1947 Publication of *Jazz.*

1948–1951 Matisse returns to the Hotel Regina, working from his bed by using the bamboo technique that he created in order to produce *The Merion Dance.* The chapel at Vence is inaugurated on June 25, 1951. Exhibits in New York at the gallery owned by his son Pierre (1949), then at MoMA (1951).

1952 Opening of the Musée Matisse at Cateau-Cambrésis. New series of cut-outs entitled *Sadness of the King, The Parrot and the Mermaid,* and the *Blue Nudes….*

1953 Exhibition of cut-outs in Paris, London, and New York.

1954 Produces his last cut-out, *The Rockefeller Rose.* Henri Matisse dies on November 3 and is buried in the cemetery at Cimiez.

I N D E X

B I B L I O G R A P H Y

By Henri Matisse:
Écrits et propos sur l'art [Notes from a Painter].
Compiled by Dominique Fourcade. Paris:
Hermann, 1972, new edition, 2000.

Correspondence :
Bonnard-Matisse. Preface by Jean Clair,
introduction and notes by Antoine Terrasse.
Paris: Gallimard, 1991.
La Chapelle du Rosaire. Journal d'une création.
Matisse's correspondence with Brother
Rayssiguier. Compiled and prefaced by
Marcel Billot. Paris: Le Cerf, 1993.

Books illustrated by Henri Matisse :
Mallarmé, Stéphane. *Poésies*. Lausanne:
Skira, 1932.
Joyce, James. *Ulysses*. New York: The Limited
Editions Club, 1935.
Jazz. Paris: Tériade, 1947.

Books and monographs about Matisse:
Aragon, Louis. *Henri Matisse, Roman*.
Paris: Gallimard, 1971.
Delectorskaya, Lydia. *Henri Matisse . . .
L'Apparente facilité*. Paris: A. Maeght, 1986.
Greenberg, Clement. *Henri Matisse*.
New York: Abrams, 1953.

Guichard-Meili, Jean. *Matisse. Les gouaches
découpées*. Paris: Hazan, 1983.
Labrusse, Rémy. *Matisse, la condition de
l'image*. Paris: Gallimard, 1999.
Neret, Gilles. *Matisse*. Cologne: Taschen,
1996.
Pleynet, Marcelin. *Henri Matisse*. Lyon:
La Manufacture, 1988, new edition, 1990.
Schneider, Pierre. *Matisse*. London: Thames
and Hudson, 1984.
Spurling, Hilary. *The Unknown Matisse: A Life
of Henri Matisse, Volume 1: The Early Years,
1869–1908*. San Francisco: University of
California Press, 2001.
Tout l'œuvre peint de Matisse. Introduction by
Pierre Schneider, documentation by
Massimo Carrà. Paris: Flammarion, 1982.

Exhibition catalogs:
Henri Matisse 1904–1917. Paris: Centre
Georges Pompidou, 1993.
Henri Matisse. Visages découverts, 1945–1954.
Mona Bismarck Foundation. Paris: Adam
Biro, 1996.
Matisse, un siècle de couleur. Musée Matisse,
Nice. RMN, 2000.

Laurence Millet is an art historian and a creative director of France Culture.

Photographic credits:
AKG: 56, 63, 95; Flammarion Archives: 1, 18, 19, 22, 28, 30-31, 39, 49, 57, 73, 74, 75, 77, 88, 94; Matisse Archives: 76; Baltimore Museum of Fine Art / The Cone Collection, Maryland, BMA 1950.228: 29, 96-97; The Barnes Foundation, Merion: 78-79 bottom, 66-67; The Bridgeman Art Library: 25, 40–41, 51, 53, 92; Magnum Photos / Robert Capa: 21 / H. Cartier-Bresson: 6, 80; Musées royaux des beaux-arts de Belgique, Bruxelles: 47 bottom; The State Hermitage Museum, Saint-Petersburg: 4-5, 44-45, 86-87; Museum of Modern Art, New York: 68-69; Museum of Art, San Francisco: 115; Museum of Fine Arts, Boston: 58–59; National Gallery of Art, Washington: 113; The Phillips Collection, Washington: 91; Musée Picasso photo library: 103; Réunion des Musées nationaux: 35, 52, 64–65, 70, 71, 78–79 top, 102 / Gérard Blot: 9, 10, 81 / Gérard Blot et C. Jean, p. 14-15 / CNAC/MNAM: 8, 16, 32, 33, 60, 89, 101, 104, 108, 109 / A. Danvers: 55 / Philippe Migeat: 110 / H. del Olmo: 36–37 / Jean-Claude Planch: 105 / Jean Schormans: 98–99 / Mnam-Cci photo documentation department: 61; Rue des Archives: 12, 13, 23, 24, 47, 107; Scala: 111, 26-27, 42-43, 72, 82-83, 85; Statens Museum for Kunst, Copenhague: 2, 62; Tate Gallery of Modern Art, London: 50; Wally Findlay Galleries, New York: 114.

Translated and adapted from the French by Josephine Bacon
Copy-editing: Penelope Isaac
Typesetting: Claude-Olivier Four
Proofreading : Christine Schultz-Touge
Color separation: Pollina, S.A., France

Originally published as *L'ABCdaire de Matisse* © 2002 Flammarion
English-language edition © 2002 Flammarion
ISBN 2-0801-0885-9
N° d'édition: FA0885-02-VIII
N° d'impression : L87298A
Dépôt légal: 09/2002

Printed in France

Pages 4–5: Matisse, *The Dance*, 1900–1910. Oil on canvas 102 x 154 inches (260 x 391 cm). The Ermitage Museum, St. Petersburg.